The Untold Story

The Untold Story

Women and Theory in Golden Age Texts

Mary S. Gossy

Ann Arbor
THE UNIVERSITY OF MICHIGAN PRESS

Copyright © by The University of Michigan 1989
All rights reserved
Published in the United States of America by
The University of Michigan Press
Manufactured in the United States of America

1992 1991 1990 1989 4 3 2 1

LIBRARY OF CONGRESS CATALOGING-IN-PUBLICATION DATA

Gossy, Mary S., 1959–
 The untold story : women and theory in Golden Age texts / Mary S. Gossy.
 p. cm.—(Women and culture series)
 Includes bibliographical references.
 ISBN 0-472-10132-3 (alk. paper)
 1. Spanish literature—Classical period, 1500–1700—History and criticism. 2. Repression (Psychology) in literature. 3. Women in literature. 4. Prostitutes in literature. 5. Witchcraft in literature. I. Title. II. Series
PQ6066.G68 1989
860.9'003—dc20 89-20264
 CIP

Acknowledgments

The ideas for this study came together and began to take shape during the years 1981 through 1988, at Bryn Mawr College and at Harvard University. Each of those institutions, whether officially or not, was a place where communities of sensitive and intelligent people appeared, at just the right times, to share the insights and criticisms that served to catalyze this work.

Willard King and Enrique Sacerio-Garí initiated me into intellectual history and literary theory. The late Eleanor Paucker helped me to learn to love Spain.

Barbara Johnson and Joaquim-Francisco Coelho encouraged and inspired me to complete the study; it could have been, but would not have been, done without their generous support and sensible readings. I am most immediately and profoundly grateful to them.

Stephen Gilman's kindness and encouragement helped me to begin on the path that eventually led here. His sensitivity to the oppressed, from *conversos* to more recent peoples, is one of the sources for this book.

The gentility, expertise, and good sense of LeAnn Fields of the University of Michigan Press and Ross Chambers of the Press Editorial Board have made the job of publication a pleasure.

Carl Kirschner and members of the Department of Spanish, and the Henry Rutgers Research Fellowship of Rutgers University, gave support that made it possible for me to complete the manuscript with only minimal distraction.

I have learned that, in addition to its dependence on an intellectual

Acknowledgments

community to foster it, a book needs someone to give its author enough emotional support to be able to endure its writing. My father, mother, and sister were always there when I called, whether my noises were of triumph or despair. The same is true, in a varying mode, of Susan Austrian, M.D., whose endurance is matched only by her compassion.

Louise Wills, my comrade in theory, made sure I danced enough to keep my brain capable of meeting her intellectual thrusts and parries and dared it to go with hers to where no man's had gone before.

Michael Berthold read and re-read chapters, stir-fried, called long-distance, and made me believe not only that this project was worth doing but that I could do it. When even his extraordinary eloquence and wit could not persuade, he made sure that the Smiths and Prince did.

Charlene Ray is the bravest of them all. She has, without respite, encouraged, entertained, cajoled, protected and challenged me to keep on keeping on. I owe her my warmest gratitude; for all that, and for all the rest, thank you.

Chapter 4 is for Klomp.

Contents

CHAPTER

1. The Untold Story and Spanish Literature 1
2. A Theory of the Untold Story 5
3. Hymen and Text in *La Celestina* 19
4. Marriage, Motherhood, and Deviance in *El Casamiento engañoso/Coloquio de los perros* 57
5. Voyeurism and Paternity: Reading *La tía fingida* 83
6. *Convivencia* and Difference: The Untold Story in *Libro de buen amor* 111

Notes .. 117

Bibliography 135

CHAPTER I

The Untold Story and Spanish Literature

This study uses contemporary literary theory—in particular, narratological, feminist, reader-response, and psychoanalytic theory—in order to discuss the function of the repressed in narrative and how repressed themes, characters, genres, or literary traditions are interpreted by dominant meaning systems.

Specifically, the study investigates the functions of deviant women—witches and prostitutes—in a tradition that is itself marginalized from contemporary theoretical inquiry. With the exception of *Don Quijote* and the texts associated with the Don Juan myth, twentieth-century theoreticians have paid little attention to works of the Spanish renaissance, despite the fact (or perhaps because of it) that the works had a strong effect on the development of Western literature and social life. Many of the texts discuss problems of imperialism, decadence, heterodoxy, and political repression that are relevant to analyses of changes at work in literature, interpretation, and society in the late twentieth century. Nevertheless, what Spain, with its history of both tolerance and orthodoxy, might have to say about the Western condition has not yet been heard.

Similarly, few Hispanists have transgressed the boundaries of methodological ideology in place around canonized Spanish texts.[1]

This tendency to avoid contemporary theoretical discussions deprives Golden Age scholarship of valuable insights and perpetuates the isolation of Spanish literature from the vanguard of critical discourse. As a result, both literary theory and Hispanist studies miss perspectives crucial to full investigations of the issues and questions facing each discipline. Literary scholarship in general is deprived of an acquaintance with a culture that in many ways thrived between traditional Western cultural oppositions and of the lessons to be learned from that culture's experience of moving from great internal difference to enforced orthodoxy. This study thus attempts an intersection between contemporary theoretical issues and Spanish texts that are important to their understanding and elaboration.

At the beginning of the discussion, I propose that filling in the gap that is the untold story in a text has come to seem necessary to the practice of reading and to the production of narrative. This untold story is a part of a text that makes its absence felt, and upon whose felt absence the form and process of the text depend. In *La Celestina,* a poetics of the untold story is elaborated in connection with Celestina's activity as hymen mender. In *El Casamiento engañoso/Coloquio de los perros [Deceitful Marriage/Colloquy of the Dogs],* the untold story is connected to marriage and maternity. *La tía fingida [The Pretended Aunt],* which makes explicit and connects stories of hymen mending, prostitution, and witchcraft, pays for its outspokenness by being untold by structures of literary legitimization. The connection of women's bodies to the production of meaning in patriarchy is examined, and the reader's response to a gap is linked to his response to a terrifying, dark, unbounded unknown, which tends to be gendered feminine by critical discourse.

In other words, the untold story is an intolerable gap in a text that the reader feels a compulsion to fill. The theoretical introduction (chap. 2) is an attempt to show how some contemporary critics have read the gaps in texts. One aim of this is immediately to situate the argument in terms of contemporary theory; another aim is to show how the gaps in a text are often treated by the

reader as a fetishized feminine object.[2] This assertion poses a question to the theory of reading in general. If, as Jacques Lacan has it, the accession to language requires compliance with the law of the Father in the Symbolic, does reading, too, require that the reading subject ally himself with the Father? That is, does reading require (regardless of the gender or sexual identification of the reader) a patriarchal approach to a feminized text object? This comment suggests the possibility of a *lecture féminine* analogous to the concept of *écriture féminine*. But, as is well known, not all writing by women is *écriture féminine*. Presumably, not all reading by women would be *lecture féminine*, either. Academic reading, in particular, seems to be given to an approach and vocabulary of penetration, legitimization, ownership, production, and naming consistent with value and meaning systems in place in patriarchy. For this reason, when I refer to a generalized reader, I intentionally use the masculine pronoun as a means to urge the reader constantly to problematize and to question the reading processes she or he employs. It would be interesting to elaborate a theory of *lecture féminine*, but that is not within the province of this study, which is descriptive, rather than proscriptive or prescriptive, of functions at work in the creation of narrative and its reception. That I have been conscious of not wanting to fill in gaps, or to tell untold stories, is indicative of my positionality in this discourse. What I have tried to do is to elicit meaning from the detail[3] surrounding the gap; that is, to describe its surroundings, rather than to inscribe the gap itself.

My aim has been to examine the erotic dimensions of reading practices in patriarchy in three works that seem emphatically to problematize those practices in terms of the relationship of undefinable women characters, and their equally undecidable bodies, to the orthodoxy of the narratives in which they appear.

CHAPTER 2

A Theory of the Untold Story

The untold story is that part of a text[1] that makes its absence felt, and upon whose felt absence the form and process of the text depend.

Indications of the untold appear in the theoretical works of some recent critics who, although they have mapped some of its traces, have not yet synthesized the literary, psychological, and political manifestations of the untold into a whole.

Gérard Genette describes the way the untold shows itself narratologically in the place where

> the narrative does not skip over a moment of time, as in an ellipsis, but it *sidesteps* a given element. This kind of lateral ellipsis we will call, conforming to etymology and not excessively straining rhetorical usage, a *paralipsis*.[2]

Colloquially, the phrase "sidesteps a given element" makes sense, *given* meaning some (unspecified) element. In a narrative context, though, how can the reader know that an element is "given" if it has been sidestepped, that is, if it is not there? Genette does not develop the possibilities of his statement, but his interest points to the first salient quality of the untold: its absence calls

attention to it. What is not there draws the reader's attention and demands notice.

Yet, as the etymology of *paralipsis* indicates, the missing element is not essentially absent; rather, it has been actively put aside in some conscious or unconscious process of selection. The order imposed on the text requires that the untold be moved over; the manifest structure of the text depends upon the subordination of the untold. For this reason, the untold tends to adhere to the edge of a text, whether that be a marginal theme, character, language, genre, or ideology. A dominant discourse pushes the untold to the extremities of the text.

Genette says that

the gaps, the interruptions of the text are not mere absences, a pure non-text: they are a lack, active and perceptible as lack, as non-writing, as non-written text.[3]

In this statement he touches upon another critical aspect of the untold: because it is perceived as a lack, it becomes an object of the reader's desire, an emptiness to be filled. Consequently, it is also an irritant to the reader who definitely would fill it in, because it is impossible to penetrate and own; the untold is necessarily and essentially not tellable. Nevertheless, filling in the spaces that are part of the untold is a matter of interest to phenomenological/reader-response critics, who have been the ones to discuss most thoroughly the question of gaps in the text. Theories of "spots of indeterminacy" (*Unbestimmtheitsstellen*)[4] and "gaps" are integral to the constructs proposed by Roman Ingarden and Wolfgang Iser.[5]

Ingarden defines a "spot of indeterminacy" as follows:

If, e.g., a story begins with the sentence: "An old man was sitting at a table," etc., it is clear that the represented "table" is indeed a "table" and not, for example, a "chair"; but whether it is made of wood or iron, is four-legged or three-legged, etc., is left quite unsaid and therefore—this being a purely intentional object—*not determined*. The ma-

terial of its composition is altogether unqualified, although it must be some material. Thus, in the given object, its qualification is *totally absent:* there is an "empty spot" here, a "spot of indeterminacy."[6]

. . . during his reading and his aesthetic apprehension of the work, the reader usually *goes beyond* what is simply presented by the text (or projected by it) and in various respects *completes* the represented objectivities, so that at least some of the spots of indeterminacy are removed and are frequently replaced by determinations that not only are not determined by the text but, what is more, are not in agreement with the positively determined objective moments.[7]

A *represented objectivity* is analogous to Genette's *what is given:* what the text shows and tells. The "spot of indeterminacy" is what the text does not give. Ingarden, according to this quotation, sees reading as a threefold act consisting of projection (going "*beyond* what is simply presented by the text"), replacement (completing "the represented objectivities," which implies that the spaces in the text are incomplete) and redefinition (supplying "determinations that . . . are not determined by the [text's] . . . positively determined objective moments"; or what we might call retelling). In his argument there is also at work the assumption that these spots should be filled:

[T]he representing states of affairs designate a strictly circumscribed manifold of *possible* completions of the spots of indeterminacy, from which we may choose some in the course of reading if we wish to effect this completion in accordance with the already established determinations of the represented objects. . . . [O]n the other hand, the textually established states of affairs are not sufficient for designating a strictly circumscribed manifold of possible completions. In that case, each "completion" or approximate completion actually effected in this way is fully dependent on the reader's (or in a stage play—the director's) discretion.[8]

In the present scheme, the reader first decides that indeterminacy means incompleteness and lack, which he must fill in order to read. He then seeks to name the untold, to fill in what he

perceives as its blank with a word, a *logos* of his own making. Interestingly enough, this scenario parallels the psychology of the idealized romantic love ethos. The lover projects his idealized fantasies upon his love object; the lover's fantasies spatially or physically overpower the object's subjectivity; the lover eradicates that subjectivity and replaces it with his own definition of what the beloved should be. (The use of the subjunctive is not accidental; despite the forcefulness and thoroughness of the lover's procedure, his results are still contrary to fact.) If we transpose the analogy back into a literary mode, we can see that the reader's approach to the gaps in a text conditions the text's meaning for him (and for his readers, if he is also a critic).

Ingarden's scheme makes the process of the rewriting of the unwritten text so complete that he can say that ". . . while reading a work we are not conscious of any 'gaps,' any 'spots of indeterminacy' in the represented object."[9] For a reader reading according to this plan (and it seems that Ingarden and Iser are accurate in their observations of how we learn to read, of the processes habitually inculcated and at work) the repression (by immediate filling in) of the gaps in the text is automatic. But, as immediate as it may seem, it is never as thorough as it needs to be: ". . . represented objectivities . . . can *never* be *entirely* filled by material determinations."[10] What happens when a reader acknowledges, in the process of reading, that the space is not fillable, that no concretization is big enough to do the job, that perhaps the job need not be done? One characteristic response is to negate the gap's thingness while at the same time admitting that the gap is essential to the reader's intercourse with the text. Thus, Iser can say that "the first structural quality of the blank, then, is that it makes possible the organization of a referential field of interacting projections";[11] that, as in Ingarden's plan, the gap (or spot of indeterminacy) is integral to the reader's apprehension of the text, and that it is a hole to be filled in by the reader. Iser continues, ". . . the blanks have no existence of their own, but are simply empty spaces in textual structures, denoting a need for determinacy."[12] There is a logical disjunction between the two com-

A Theory of the Untold Story

ments. The first admits presence, being, even a "structural quality," a *form* for the blank that in the next quotation is only an absence, a receptacle awaiting the insertion of the reader's determination. The critic seems to be following, with the appropriate transpositions into literary metaphor, the standard Freudian description of femininity as lack and of phallus as remedy for that lack. If we are willing to extrapolate along psychoanalytic lines, we may begin to wonder if the ambivalence and fear of the other implicit in the Freudian construct pertains also in a reader's approach and response to the text's gaps. If it does, the reader in this situation experiences the gap in terms of male paranoia.

Male paranoia involves, fundamentally, the fear of the loss either of all boundaries or of those boundaries becoming too painfully constrictive. And this encounter with boundaries is almost always described by men as an encounter with what is called "God"—that being who has no boundaries.[13]

The untold as unreadable gap, that is, as not under the reader's control, is just such a being that has no boundaries. The reader's awareness of the other that is the untold leads to fear; the fear leads to a desire to dominate and erase the difference of the other. On a literary plane, this means that according to the Ingarden and Iser schemes, the untold, which will not tell itself, explain itself, and conform to the boundaries of the reader's determination, must somehow be told, and that means filling in the gap with something of the reader's own creation—a projection from himself that he can recognize as himself, thus obliterating the subjective integrity of the gap.

Iser quotes Maurice Merleau-Ponty saying, "Language is meaningful when, instead of copying the thought, it allows itself to be broken up and then reconstituted by the thought."[14] Iser continues:

> The text is a whole system of such processes, and so, clearly, there must be a place within this system for the person who is to perform

the reconstituting. This place is marked by the gaps in the text—it consists in the blanks which the reader is to fill in. . . . Whenever the reader bridges the gaps, communication begins. The gaps function as a kind of pivot on which the whole text-reader relationship revolves. Hence the structured blanks of the text stimulate the process of ideation to be performed by the reader on terms set by the text. [I.e., ideation can only fill in holes where they are present in the text.][15]

Both critics see the reader's act of filling in the empty spaces in the text as fundamentally necessary to the act of reading; it is their position that no aesthetically successful act of reading can occur unless the reader fills in the holes as best he can.

Projection is the main force implicit in both Sigmund Freud's and Iser's constructs, and because of this the autoerotic dimensions inherent in both cannot be overlooked.[16] The reader will not accept what is other—because of fear, ambivalence, paranoia, or a very realistic dread of the subversion inherent in the untold. He names the menacing and unintelligible subjectivity of the space a lack and then proceeds to fill the imagined lack with himself, all to the end of ". . . organiz[ing] a referential field of interacting projections"—his own projections interacting with each other, with the result that ". . . we can watch what we are producing, and we can watch ourselves while we are producing it."[17]

But this autoeroticism is latent; it lacks the qualities of reciprocity and erotic charity that might attend an openly emotive and erotic relationship with oneself or another, or the type idealized in Iser's caution:

Balance can only be attained if the gaps are filled, and so the constitutive blank is continually bombarded with projections. The interaction fails if the mutual projections of the social partners do not change, or if the reader's projections superimpose themselves unimpeded upon the text.[18]

The problem with this statement is that it ignores the possibility of a gap in the text that is not protected by information and

A Theory of the Untold Story

negations that can control or impede the reader's ideation—in other words, a gap without boundaries, which we are calling the untold. This formulation leaves such a gap, the untold, subject to imbalance, projection, rewriting, overtelling. This strategy is analogous to the unacceptable but undeniable autoeroticism habitually sublimated in Western literature in the form of the sadomasochistic triad of death, honor, and romantic love: whether for a god, a nation, or a woman. All of these idealized objects are projections of the self seeking itself as a solid in unfamiliar and apparently insubstantial boundless space. The effect on the untold of the reading strategy that is analogous to the repressed, paranoid sexuality described above is the same as the effect of that construct on human interaction. The threatening space is objectified (deprived of the power of its own subjectivity) and then eroticized and possessed as an extension of the self, although it is called an other. The space of the untold is filled with something recognizable, an act of ideation acceptable to the reader's consciousness—instead of being left empty and apparently textless. (It may really be textlike but not in a way tolerable to the reader.)

In his discussion of "negativity" Iser comes closer to an awareness of a space in the text that might not need to be filled, a space, in fact, like the untold, whose emptiness is necessary to the text's process. He says that

> practically all the formulations of the text refer to an unformulated background, and so the formulated text has a kind of unformulated double. This "double" we shall call "negativity." . . . [19]

Negativity has "at least three" features (226); the first relates to form, the second to content, and the third to communication. Formally, negativity is the space that links the

> individual positions of the text . . . ; it is the "nothing" between the positions which enables them to be related and comprehended[;] [analogous to Sartre's silence between the notes of music] in relation to the

given positions which it links, negativity traces out what is not given and enables it to be communicated.[20]

In regard to content, Iser believes that negativity is allied to "failure and deformation" in character and events. The occurrence of these problems provokes the reader to seek their cause. Negativity, then,

translates the deformed positions into a propellant which enables the unformulated cause to become the theme of the imaginary object ideated by the reader. . . . [I]t embraces both the question and the answer.[21]

For Iser negativity is both the cause of the deformation and its solution. Failure and deformation, like madness, nature, other, unconscious, have been traditionally gendered feminine. Here negativity seems to function like a simultaneously destructive and nurturing feminine principle.

Finally, negativity spurs communication by being the unknown of the text that the reader wants to know. It

is the structure underlying the invalidation of the manifested reality. It is the unformulated constituent of the text. As far as the reception of the text is concerned, negativity is that which has not yet been comprehended. . . .[22]

It is that which keeps the reader thinking about the text. The place to which negativity leads, naturally, is the most hidden part of the text, or the one least obvious in conventional reading strategies.

Like negativity, the untold is called nothing, yet it is integral to the text's process. As negativity is linked to failure and deformation in plot and character, so does the untold attach itself to what seems failed or deformed in the traditional Western view, and, particularly in the Spanish context I will discuss, heretical or unorthodox characters. Like these, and negativity, the untold is not yet known and subversive in the text. Judging from Iser's

A Theory of the Untold Story

description, we can say that negativity leads to the other part of the text, to unacceptable meanings, readings, ideations. Iser's fear of what negativity can produce in the reader mystifies him, who otherwise thoroughly and fearlessly describes the intricacies of extremely complicated reading situations, and makes him write: "If we were able to explain its effect, we would have mastered it discursively and would have rendered obsolescent the experience it provides."[23]

So negativity would lose its power if it were understood. Actually, if its operations were taken to their conceivable conclusions, neither the text nor the reader would lose potency—but possibly there would be an uncomfortable encounter with the text and somehow subversive ideas might occur. Rather than losing its power when its effects are explained, the untold gains and gives power: to the detextualized edges of a work. Iser is still afraid of these parts of the text.

Why is this space, which is the domain of the untold, so threatening? Iser gives some clues in his discussion of the function of the blank in the *roman á thèse*. *Romans á thèse*, he points out, must be almost completely free of gaps in order to attain their goal: to guide the reader to a predetermined, specific conclusion. Ideation must be carefully guided and impeded in order to assure this end. Gaps and the uncontrollable projections they can provoke must be limited, or the reader will miss the point.[24] The message behind this is clear: gaps are subversive, not just to the propagandizing of the *roman á thèse*, but to the meaning of any text, regardless of genre—whether that meaning be intended by the author, or (much more likely) intended and demanded by the canonized critical opinion on a given text. Like woman in man's world, they are necessary and unavoidable but dangerous.[25]

Susan Rubin Suleiman suggests that

> the hallmark of modernist and postmodernist texts is that they *frustrate* the reader's compulsion for synthesis and *invite* the fragmentation against which the reader seeks protection in a total object, or in a single meaning—whence the threatening or "terrorist" qualities of such works, to which many readers react with veritable fear and loathing.[26]

THE UNTOLD STORY

The untold in any text functions the way that Suleiman says modernist and postmodernist texts do. The key words describing its operation are the ones she has italicized: *frustrate* and *invite*. The reader sees it as simultaneously rejecting his advances and inciting them: the untold is the hyphen (or, as we will see later, the hymen) between Madonna-whore. The untold is not a perfected moment in the text (and it is sometimes marked by, but not equivalent to, an area of a slippage, or the *supplément* of, deconstruction); it is a tension between frustration and invitation where neither synthesis nor fragmentation can be achieved or avoided by the reader. It is the place *between* in the text—the empty space without which the weave could not be woven, or unraveled. The activity of the untold is Penelope's silent pulling of the narrative thread. The process of the *Odyssey* depends upon her own story remaining untold. She sits quietly; her textile is the only sign of her (subordinated) story, and upon its unmaking depends the construction and resolution of the epic.

Roland Barthes observes this fall of the cloth and says:

L'endroit le plus érotique d'un corps n'est-il pas *là ou le vêtement baille?* Dans la perversion (qui est le régime du plaisir textuel) il n'y a pas de "zones érogènes" (expression au reste assez casse-pieds); c'est l'intermittence, comme l'a bien dit la psychanalyse, qui est érotique: celle de la peau qui scintille entre deux pièces (le pantalon et le tricot), entre deux bords (la chemise entrouverte, le gant et la manche); c'est ce scintillement même qui seduit, ou encore: la mise en scène d'une apparition-disparition.

[Is not the most erotic portion of a body *where the garment gapes?* In perversion (which is the realm of textual pleasure) there are no "erogenous zones" (a foolish expression besides); it is intermittence, as psychoanalysis has so rightly stated, which is erotic: the intermittence of skin flashing between two articles of clothing (trousers and sweater), between two edges (the open-necked shirt, the glove and the sleeve); it is this flash itself which seduces, or rather: the staging of an appearance-as-disappearance.][27]

Like Ingarden and Iser, Barthes, too, finds himself desiring the untold in the text. Interestingly enough, though, his purpose in

A Theory of the Untold Story

reading the text is not to fill in its hole—perhaps this is why his desire as reader is perverse: because it does not follow their patriarchal paradigm—but rather to appreciate the scintillation of the space itself, as it is, alternately covered and uncovered and unfilled. For him the most erotic part of the text is its *intermittence,* its breaks and spaces, the part, speaking etymologically, that is "sent between" the weave of words. Not coincidentally, Barthes's metaphor for this phenomenon is clothing, what is made of cloth— he feels the textual textile and the allure of the spaces in it.

The idea of *between* comes up five times in this short quotation: in inter*mittence,* entre *deux pièces,* entre *deux bords,* entr*ouverte,* and on the thin mark of the hyphen between *apparition-disparition.* What is between is the core of the text, that upon which the reader's desire and the reading of the text depend. Suleiman alludes to this between, too, although more obliquely; both she and Barthes note the aesthetic necessity of the unfilled hole; to both its significance as unfilled is apparent. But neither critic moves beyond a view of the untold as object of fear (the untold as "threatening or 'terroristic' ") or of desire ("L'endroit le plus érotique" of the text). Neither argument tries, in a fit of paranoia, to erase the difference of the untold, but both treat it as other, with fear and desire—and regardless of sexual preference, this has been the patriarchal approach to the feminine in Western culture and the reader's approach to the text.

Lacanian theory helps to explain the fear wed to this desire. In Lacan's construct, the analogy to the untold is desire itself, the yearning in unfillable space for a return to the unified being that is the child's in the unbroken mother-child dyad—the couple that is fragmented by the Father's law, and whose fragmentation precipitates the now split subject's accession to the limitations and power of language. The law in Western culture has been that children

start by desiring their first object: the mother. In fantasy this means having the phallus which is the object of the mother's desire (the phallic phase). This position is forbidden [by the father] (the castration complex) and the differentiation of the sexes occurs [along with the acces-

sion to language]. . . . Henceforth the girl will desire to have the phallus and the boy will struggle to represent it.[28]

Both children seek the phallus because it seems to be the way back to the now prohibited body of the mother—to whom the Father, with his phallus (meaning not only the organ but also all that it signifies in patriarchy) has privileged access. But no action or word on the part of the child or any other being can restore the lost unity of the original dyad; the child has come under the law of the unsatisfactory realm of language.

The baby's . . . desire only exists because of the initial failure of satisfaction. Desire persists as an effect of a primordial absence and it therefore indicates that, in this area, there is something fundamentally impossible about satisfaction itself.[29]

[Desire] can be defined as the "remainder" of the subject, something which is always left over, but which has no content as such. Desire functions much as the zero unit in the numerical chain—its place is both constitutive and empty.[30]

What Lacan calls "desire," then, like the untold is both "constitutive and empty." As movements of will "with which we try vainly to plug the gap at the very centre of our being"[31] try to satisfy desire, so the reader tries ineffectually "to plug the gap" of the untold (Terry Eagleton, whom I quote, frequently uses phrases like this in his discussion of Lacan). He is like the child in this construct: in painful conflict. He wants to fill the gap because then he can forget the loss of his original halcyon state. But fearfully he acknowledges that the gap is not fillable, that it is too late. Almost as bad is to realize that the system according to which one (seemingly) must exist, is . . . "constructed, in a division which is both arbitrary and alienating," that the "whole and certain"[32] sexual or critical identity upon which his survival depends is a convenient (to some) fiction; to recall Barthes, that sex is text, a fabrication. The holes in that cloth let the reader see

A Theory of the Untold Story

uncomfortably through the tenuous legitimacy of gender structures—and of textual interpretation.

The relation of the reader to the text is that of desiring masculine to desired feminine—following the mechanics of the Western paradigm, in which space "nature, other, matter, unconscious, madness, hylé, force have . . . carried feminine connotations (whatever their grammatical gender)."[33] Complete the spots of indeterminacy; ideate in the gaps: his wholeness is intent on filling in what he perceives as her lack. The untold in a text produces in the reader an aesthetic response analogous to Lacanian desire. The holes that cannot be filled by predetermined projections are a menace to the reader's literary or political orthodoxy; they are also an irritating reminder of its perpetual incompleteness, of the fact that a reader's desire for the last word will never be satisfied.

CHAPTER 3

Hymen and Text in *La Celestina*

The critics discussed in chapter 2 say that the gaps, spots of indeterminacy, spaces, and negativity that mark the untold in a text are empty, missing something, incomplete, deformed, not normal, or mystifying and unfathomable. Those words are some adjectives often used in common parlance and metaphor to describe the vulva. I have tried to indicate that readers tend to approach the untold symbolically as a vulva; that is, as frightening evidence of a powerful and desirable difference that must, because of the fear and insatiable yearning it stands for, be erased and made, somehow, the same. (It is important to note here that *phallus* and *vulva,* in this argument as in psychoanalytic theory and feminist theory, are symbolic constructs and signifiers of many signifieds other than the organs to which they anatomically refer.) Of course, Iser, Ingarden, and Lacan are not the only theorists who have discussed gaps and negativity, but the canonization of the first two as champions of reader-response criticism and of the last as a psychoanalytic language theorist shows that these writers' stances toward gaps in reading have been at least implicitly accepted as norms.

In other words, it seems possible that readers (whether male or female and regardless of sexual orientation) tend to approach the untold in the text in a dominating, violent, and somewhat

paranoid way that is similar to modes of sexual objectification that manifest themselves in patriarchy.

Much of *La Celestina*[1] is about desirable and all-consuming objects of sexual desire, what they do, what they do not do, what is done with and to them. It is a text that at least on the plot level is the written record of a series of conversations about the limits, possibilities, and extremities of sexual conquest, a narrative process of trying to fill the physical hole in the vulva, and the deeper hole that is desire. Because of its subject matter, *La Celestina* is useful for a discussion of how texts metaphorize gaps and how readers read them.

Additionally, the text is a remarkable multiplicity of genres, styles, and social perspectives. It is influenced by both the tradition of the *comedia humanística* and the most popular literary genre of its time, the *relato sentimental* (sentimental narrative).[2] It is a novel in dialogue form; it is uncertain to this day whether it was intended for dramatic recitation or more private reading, so it straddles the line between novel and drama.[3] Its characters speak in a variety of styles consciously suited to provoke inappropriate reactions and misconceptions in their hearers.[4] Calisto talks like the hero of a *relato sentimental;* Sempronio like a schoolman or a rogue; Pleberio like a neo-Stoic Petrarchist;[5] Celestina like a doting mother or a bawd. As such, the text is an exercise in reader response and interpretation: each character is an author of fictions, and an interpreting reader of others' stories. In the midst of spinning lies, and the multiplicity of almost every aspect of the text, each character tries to interpret gaps in the lies he interprets, hoping to fill them in with a certain meaning that might lead to the object of his desire.

The critical response to gaps in and related to *La Celestina* has, to some extent, reflected and repeated the fictive and interpretive economy of the text.[6] Scholars work to establish the authorship of the text, the genre to which it pertains, its morality, and its location.[7] In the main, these questions stem from the fact that because of the lack of a *princeps* manuscript, there is no proof of the authorship of the first *auto* (act). Also, the story's genre and

morality cannot be demonstrated experimentally, and the text does not make explicit the locale of its action. Yet, despite these unfillable holes within and without the text, much effort has been expended in attempts to name, to fix, or to pin down—despite its elemental deviousness—*La Celestina*.[8]

One of the first known critics of *La Celestina* is Juan de Valdés, whose 1535 *Diálogo de la lengua* [*Dialogue on the Language*][9] raises early on the questions that most preoccupy nineteenth- and twentieth-century critics. To initiate his discussion, Valdés mentions the authorship question:

Celestina, me contenta el ingenio del autor que la començo, y no tanto el del que la acabó; el juizio de todos dos me satizfaze mucho. . . . (182)

[*Celestina*, I like the wit of the author who started her, and not so much that of he who finished her; the intelligence of both is quite satisfying. . . .]

Valdés assumes that the work had more than one author but rather than attempting to fix an identity simply makes an aesthetic judgment on the text. Four centuries later, scientific methods of investigation made possible the hope of establishing the precise identity of one or more authors of the text. Unfortunately, *Celestina*, from its beginning, resists schematizing and attribution.

The introductory material to the text states that its authorship and genre are unclear. Fernando de Rojas, in his *El autor a un su amigo* [*The Author to a Friend*], which serves (since the 1500 Toledo edition)[10] as a preface to the text, says that he based his work on a manuscript, comprising the first *auto*, that "Vi que no tenía firma del autor" (36) [I saw that it did not have the signature of its author]. Some editions suggest that Juan de Mena or Rodrigo Cota was the source,[11] but despite much effort and long study, no incontrovertible evidence has been found to prove, beyond a doubt, the authorship of what became the first *auto* of *Celestina*. It must be appreciated that the work to establish the authorship of the first *auto* has provided a great deal of new information

about the literary and cultural history of late fifteenth- and early sixteenth-century Spain, but it has not filled in the blank with any name.[12]

The fact that there are two versions of *La Celestina*, the 1499 *Comedia de Calisto y Melibea* (sixteen *autos*) and the ca. 1502 *Tragicomedia de Calisto y Melibea* (twenty-one *autos*),[13] further complicates attempts to ossify its elasticity: it is simultaneously two works and of two genres, narrative and dramatic.[14] Valdés knew the work as the "tragicomedia" (182) and does not give evidence of discomfort respecting its genre. What he does next is to air some doubts about characters' motivation and the morality of the story.

After his interlocutor Marcio asks him what he thinks of the various characters, Valdés replies that Celestina, Sempronio, Pármeno, and Calisto are fine, but

la persona de Melibea pudiera estar mejor . . . A donde se deja muy presto vencer, no solamente a amar pero a gozar del deshonesto fruto del amor. (182)

[The character of Melibea could be better . . . in that she lets herself give in very quickly, not only to loving but also to enjoying the immodest fruit of love.]

The question of the text's moral (or lack of moral) didacticism has been of interest since Juan Luis Vives first suggested in *De Institutionis Feminae Christianae*[15] that it be kept out of young ladies' libraries. In the twentieth century the debate about the book's morality has tried to decide what the author's (or authors') philosophy of love and death was and whether or not he (or they) had a didactic intent in writing it.

Marcel Bataillon and María Rosa Lida de Malkiel represent two dominant strains of thought about the moral intent of the text. Bataillon attempts to prove that sixteenth-century readers interpreted *La Celestina* as a moralizing work, basing his argument on a reading of Gaspar Barth's 1624 introduction to his Latin translation of *La Celestina*, titled *Pornoboscodidascalus*. Ac-

Hymen and Text in La Celestina

cording to Bataillon, Barth "sees the [*Celestina*] as a precious manual of practical morality."[16] Lida de Malkiel understands the text as an articulation of the amoral, egotistical conflict described in its prologue—as the expression of the unceasing infighting and destruction at work on all levels of the material world.[17] Américo Castro and Stephen Gilman situate this Ur-existentialist attitude in the historical fact of Rojas's status as a *converso*,[18] concurring that, for a *converso*, life in imperial Spain was an almost unbearable exercise in pointless cruelty and alienation.

One reason for the multiple interpretations of the book's morality has to do, again, with its refusal to produce a single, definite message. In a text whose rhetoric and content are dominated by lies—that most elementary form of fiction—it does not provoke wonder that definitive interpretations should be difficult to construct. Instead of prescribing readings to fill in the uncertainties provoked by the text, a reader may find it interesting to appreciate its remarkable slipperiness and refusal to permit authoritative reading. It negates the localization of its meaning, just as it refuses to localize its action in a factual Spanish city—again despite the efforts of readers to situate it, to lock it in one place on tangible and limited ground.[19]

The many gaps in *La Celestina*, its untold stories, are integral to its effects on readers and reading. It is a text as uncontrollable and devious as the character with whom it came to be identified—perhaps, in fact, the need to fill its gaps is a function of the identification of the text with a woman's body. Valdés is the first to do this, in Marcio's introductory comment:

¿Qué dezis de *Celestina*? Pues vos mucho su amigo soléis ser. (182)

[What do you have to say about *Celestina*? You tend to be a great friend of her.]

The absence of the article *la* or of a reference to the full literary title of the work—combined with the allusion to it as a friend—

makes an equivalence between a woman and the text. This identity becomes more emphatic a little later when Pacheco says:

> Dexáos agora, por vuestra vida, de hazer anatomía de la pobre Celestina, basta que la hizieron los moçós de Calisto. (182)
>
> [Quit now, for God's sake, anatomizing poor Celestina; Calisto's boys did a good enough job of that.]

Valdés is aware of the identity between text and woman's body in the mind of the reader-critic. A text is not a feminine body, but there is an insistence on the part of readers to metaphorize it as such and to control its unruly spaces and gaps by writing on and in it. Perhaps the only reader who has spared the gaps, while still expressing his critical opinion, is Cervantes. One of the introductory poems to *Don Quijote* includes the following lines:

> . . . según siente *Celesti-*
> libro, en mi opinion, divi-
> si encubriera más lo huma-.
>
> [as we note in *Celesti-[ne]*
> a book, to me, di-[vine]
> if it hid more human-[ity]][20]

Using the technique of breaking off the final syllable of each verse, Cervantes achieves a comic effect in these and other poems. In critical terms, though, he highlights the position of gaps and makes them, literally, integral to his interpretation of *La Celestina*.

The axis for all of this text-making and interpretation is Calisto's desire to possess Melibea sexually; perhaps it is the crudeness of his desire that Cervantes wishes had been better cloaked in the text, but the characters of *La Celestina* tend to be neither shy nor modest. It will not come as much of a surprise, then, that vulvas, in theme and imagery, accompany the untold story in *La Celestina*. One result of this is that the text represents more than a didactic caution against *loco amor* (crazy love), the disaffection and

existential anguish of a *converso* (convert) *desviviéndose* (un-living himself or herself)[21] in the restrictive atmosphere of fifteenth-century Spain, a synthesis of academic literary genres, and a triumph of innovation in characterization. *La Celestina* is also notable because its narrative economy reflects the sexual economy at work in it and at work in the process of reading. The dominant narrative reacts to the existence of the untold with desire gone to extremes of narcissism and objectification, a desire that seeks to fill the gap, and that is *loco* for the very reason that it poses an insoluble problem: the intolerable gap must be filled in order to pin down meaning, yet narrative can progress only while the desire to fill the gap yearns for, but does not achieve, satisfaction. A colleague once said, "It's all foreplay until the narrative,"[22] but it seems, rather, that narrative is all foreplay. Narrative consists of the existence, coexistence, and conflict between the told story and the untold story that it, suspended, seeks to tell itself into.

The danger of mad desire to the order of a text was evident to the author(s) of *La Celestina,* and its frightfulness is indicated by the fact that is figured in the text in the form of the time's most widely acknowledged challenge to reason, common sense, and authority: heresy. Much of the text, whether in a straightforward or an ironic way, discourses on the peril this kind of uncontrollable desire can cause to a human being, but critics see this didacticism more as a historical trait than as a rhetorical one.[23] The didacticism is seen in its ironic function and the *loco amor* of the lovers as a safe topos in which the author may express some of the terrific dread and angst of his situation as *converso*. But historically, the didactic treatment of *loco amor* in *La Celestina* is part of a tradition in Spanish literature that began at least two centuries before,[24] and whose early landmark work is Juan Ruíz, Arcipreste de Hita's *Libro de buen amor* (1343). Ruíz's narrative poem features an *alcahueta* (go-between) with three names, one of which is *Trotaconventos* (Convent-trotter), indicating her eponymous occupation: running hither and thither, from cloister to back room, supplying monks and nuns and others with amorous fodder; she is Celestina's literary ancestress. The stories are very

amusing, but the author states that his wholesome purpose is to put his medicine for the disease of *loco amor* in a sugar coating, to make it go down more easily. The didactic aim of his work, whatever his other simultaneous purposes, is accepted.[25]

Similarly, *Reprobación de amor mundano* or *Corbacho* by Alfonso Martínez, Arcipreste de Talavera, is a virtuoso lambasting of women, the cause of *loco amor,* which intends to save males from their menace. *Corbacho* influenced *La Celestina* with its continuation of the *trotaconventos* tradition (in Martínez's work the word has become generic) and with the style of its discourse. Based in part on the familiar, colloquial style used in popular sermons of the epoch and taking its spice from vulgar conversation,[26] the salty, trash-talking monologues, in various voices, of *Corbacho* helped make possible the realistic, quotidian diction of Rojas's characters.[27]

But most important to the argument at hand is the fact that Rojas takes the established didactic tradition and gives it a decidedly inquisitorial bent; *loco amor,* here, becomes a public sin, heresy, instead of something to be dealt with privately, in confession. As such it is explicitly a threat to the interdependent order of society, not just to an individual soul. Thus, the author of an introductory paragraph in the 1500 edition can say that the book was

compuesta en reprehensión de los locos enamorados, que vencidos en su desordenado apetito, a sus amigas llaman y dicen ser su dios. (44)

[written in response to crazed lovers, who, conquered by their disordered appetite, call and name their girlfriends as their god.]

It is interesting to note here the conjunction of "desordenado apetito" and "llaman y dicen ser su dios"; *loco amor* functions in this context as a heresy and as apostasy from true (orthodox Christian) faith. Partly this is because, as can be seen from the plot of *La Celestina,* the loving that takes place means to be consummated outside the church-regulated institution of marriage.

Yet this religious unorthodoxy guarantees the love's erotic orthodoxy; its extremity ensures that it will seek, in the best tradition, to own and control its object. Calisto is enamored of Melibea and will do anything to possess her sexually. He adores her and calls her his god and religion, reciting his credo in conversation with his servant Sempronio:

> Semp.—Digo que nunca Dios quiera tal; que es especie de herejía lo que agora dijiste.
> Cal.—Por qué?
> Semp.—Porque lo que dices contradice la cristiana religión.
> Cal.—Qué a mí?
> Semp.—Tú no eres cristiano?
> Cal.—Yo? Melibeo soy y a Melibea adoro y en Melibea creo y a Melibea amo. (1.49–50)

> [Semp. "God forbid, I say; what you have just said is some kind of heresy."
> Cal. "Why?"
> Semp. "Because what you say contradicts Christianity."
> Cal. "So what?"
> Semp. "Aren't you a Christian?"
> Cal. "I? I am a Melibean and I adore Melibea and I believe in Melibea and I love Melibea."]

A credo like that, made even in jest, was a dangerous thing in late-fifteenth-century Spain. In 1483, only sixteen years before *Tragicomedia's* first edition, Ferdinand and Isabella had permitted the establishment of the Inquisition, and its insistent efforts "to eradicate heresy and to enforce uniformity of belief"[28] reached into every corner of society; a love-crazed nobleman was not safe from its questions. The Inquisition had a responsibility to save the souls of heretic and faithful alike by removing heresy from the heart of the former and the society of the latter.[29] This holy mission for eternal salvation gave the Inquisitors a crusading zeal to eliminate heretics, who were construed to be "venomous reptile[s], spreading contagion with [their] very breath and . . . a

source of pestilence."[30] It is also interesting to note the homology between insanity, sin, and disease that is in place in the conceptualization of Calisto's feelings for Melibea. Here, at the very beginning of *La Celestina,* dangerously disordered desire is seen as a heresy that undermines established intellectual, religious and natural constructions. Eventually, as I will show later, the person who makes this undermining possible functions also to undermine the orthodox textual structure as well.

But at this early moment, Sempronio is the arbiter of orthodoxy; he judges Calisto's heresy to be a sin and an ailment and concludes, in order that his master's moral and physical malady not spread, that he must be cured. He says,

"No más es menester; bien sé de qué pie coxqueas; yo te sanaré." (1.50)

["No more is necessary; I know what ails you; I'll heal you."]

Sempronio knows how to heal his master, and for the next six pages he administers his cure, a diatribe that attempts to convert Calisto from the false idol who leads him astray: woman (1.50–56). His speech is firmly within the Spanish antifeminist tradition,[31] and as such is replete with examples of woman's deceitfulness, gleaned from biblical and classical sources. It is a statement of the true faith, authoritative in the scholastic sense of the word. The scene is perfectly orthodox; a woman is at the root of the trouble, just as she was at the beginning of the religious tradition, in Eden, as she is at the start of the Western literary canon, at Troy. Yet Calisto remains a staunch *negativo* before Sempronio's academic and theological attempt to convert him. He responds to Sempronio's cloisterly arguments with courtly praise for every part of Melibea's body, placing his tribute to the parts he cannot see in the emphatic position at the end of his paean:

"Aquella proporción que ver yo no pude, no sin duda por el bulto de fuera juzgo incomparablemente ser mejor que la que Paris juzgó entre las tres Deesas."(1.55)

["That part which I could not see, just from the outside I judge to be incomparably better than that which Paris judged in the three goddesses."]

The part of Melibea to which Calisto has not yet gained sensory access is the most desirable part of all. He needs someone who can help him to see the hidden part of Melibea that he cannot yet tell about, the untold secret that at this point can serve only as a screen for Calisto's projections. In this instance, the projections are archcanonical literary allusions. He tells a reassuringly old, canonical story in the gap in his knowledge of Melibea, filling a spot of indeterminacy in the text of her body with his own authoritative act of ideation. Hearing this, Sempronio understands that his master's malady is very grave indeed; his heresy is profound and invincible. He is in need of a minister of his own heterodox faith and a healer, but one who belongs to no recognized university faculty. Sempronio knows just such a doctor; and what is more, he thinks he can make money from the referral (1.58). So, he tells Calisto that he knows a way to get him what he wants:

Cal.—Cómo has pensado de hacer esta piedad?
Semp.—Yo te lo diré. Días ha grandes que conozco en fin de esta vecindad una vieja barbuda, que se dice Celestina, hechicera, astuta, sagaz en cuantas maldades hay; entiendo que pasan de cinco mil virgos los que se han hecho y deshecho por su autoridad en esta ciudad. A las duras penas promoverá y provocará a lujuria, si quiere. (1.56)

[Cal. "How do you plan to do this good work?"
Semp. "I'll tell you. For a long time I've known an old bearded woman from the neighborhood, who is called Celestina, sorceress, shrewd, on top of all the evils there are; I understand that more than five thousand virgins have been made and unmade by her authority in this city. She could move even the rocky crags to lust if she wanted to."]

With the introduction of Celestina, the narrative can begin to progress; partly because now there is a possibility that Calisto can

get what he wants, but also because something about her catalyzes storytelling activity. The formalities of Calisto's first encounter with Melibea in her garden, surrounded by courtly imagery and discourse, as well as the formula antifeminism of Sempronio's scholastic attempt to dissuade Calisto from his *loco amor,* give way to the statement, "Yo te lo diré": I will tell it to you. And what Sempronio has to tell about is Celestina's prowess in the realm of desire. She is called Celestina; she is a sorceress, shrewd, a healer; she has made and unmade five thousand virgins in one town alone, and finally, she can move even the stony crags to mad lust. Thus, at this moment, Celestina becomes the motive force of the story, displacing the *comedia* and *relato sentimental* of Calisto and Melibea, who without her can tell each other nothing. Recognizing this, Calisto says, "Podríala yo hablar?" (1.56) ["Could I talk with her?"]. Sempronio implies yes, but insists first that while he goes to get Celestina, Calisto spend his time preparing a story for her visit:

". . . estudia, mientras voy yo, a le decir tu pena tan bien como ella te dará remedio." (1.56)

["Practice, while I'm gone, how you're going to tell your problem to her as effectively as she will help you with it."]

It appears that the merit of Calisto's discourse must be commensurate with the merit of the resolution Celestina will effect. In order for it to proceed, Calisto's narrative activity must be in dialogue with Celestina's. This narrative interdependence is most clearly visible in the dialogic structure of the work, which points at the discursive symbiosis that occurs: the lover's traditional stories—the didactic *comedia,* the *relato sentimental*—can progress only if they are well told with the powerful but despised character who can make them happen. The dominant narrative depends upon hers; yet hers can exist only as an untold story on the reverse of his, since the medium of communication—in this case a love story drawing on canonized genres—belongs to him.

Hymen and Text in La Celestina

A similar symbiosis of subversive and dominant discourse occurs in Calisto's *envoi* to Sempronio, which sacrilegiously draws on biblical and liturgical themes, allusions and language:

> Cal.—Y contigo vaya. Oh todopoderoso, perdurable Dios! Tú, que guías los perdidos, y los reyes orientales por el estrella precedente a Belén trujiste, y en su patria los redujiste, húmilmente te ruego que guíes a mi Sempronio, en manera que convierta mi pena y tristeza en gozo y yo indigno merezca venir en el deseado fin. (1.56)
>
> [Cal. "And may he go with you. Oh all-powerful and ever-living God! You, who guide the lost, and who brought the three kings of Orient by means of the star to Bethlehem, and returned them to their homeland, humbly I pray that you guide my Sempronio, so that my pain and sadness may be converted into pleasure and that I, unworthy, may merit to come into the desired end."]

The juxtaposition of the story of the three wise men and the statement "so that my pain and sadness might be converted into pleasure and that I, unworthy, may merit to come into the desired end" not only indicates Calisto's heretical worship of Melibea but also creates an identity between two dissonant discourses: that of erotic love and that of orthodox religion. This identity had been allowed centuries before, when the Song of Songs was permitted in the biblical canon on the grounds that its explicit eroticism was an allegory of Christ's love for the church. But it was permitted only because in the hierarchy of the allegory carnal love was elevated to a spiritual plane. Yet even canonized, such a conflation of erotic and religious discourse was the occasion of much trouble, at least to Fray Luís de León, the great poet and theologian, who spent five years (1572–77) in a prison of the Inquisition for translating the text into Spanish and (it was alleged) suggesting that the work was "an amatory dialogue between the daughter of Pharaoh and Solomon."[32]

The suggestion that an erotic encounter could be narrated in what had by then become religious language was cause for the worst kind of censure. Yet Calisto takes the conflation a step

[31]

further and inverts the allegory. When Calisto puts his *loco amor* into the discourse of religious orthodoxy, the text achieves two ends: First, it lampoons the restrictive orthodoxy that so tormented *conversos* and others in Spain from the author's time through Fray Luís's and for a century more.[33] Second, it shows in two ways the dependence of a subversive discourse on the dominant discourse it seeks to undo. Calisto could not fully express the extremity of his erotic feelings if he were unable to code them in the language reserved for adoration of and supplication to the greatest of the powers that be. The Christian God, in his society, is the highest good; orthodox faith as dictated by the church, the greatest truth. Melibea is Calisto's highest good; his love for her, his only faith. He can adequately articulate these heresies only with the orthodox language of faith and truth, the established discourse of the religion that forbids what he so earnestly solicits. The fixing of the text in a didactic tradition, with various modes of rhetorical orthodoxy in place, may be an attempt to save it from censure directed at its often unorthodox subject matter. A painful coexistence of conflicting literary modes seems necessary to the production of narrative.

On the other hand, Calisto's invocation is really most correct; as religiously heretical as his expression of his feelings may be, the feelings themselves are erotically orthodox and follow perfectly the straight and narrow path of objectifying desire. Calisto does not want communication with Melibea (as subject) at all: the goal he seeks in his prayer is "venir en el deseado fin"—to come into the desired end. Calisto's urge is to come into an undefined, unnamed, desired space, to move into it, to fill it with himself.

The words "venir en el deseado fin" bring to an end the introductory portion of the first *auto,* and the silence that follows them foreshadows the fact that, without the operation of an untold story, a desired element into which no one has come, the dominant narrative will cease to progress. To come, objectifyingly, to "el deseado fin" is, precisely, to come to the end of narrative.

The next voice we hear after Calisto's "fin" is Celestina's. She

Hymen and Text in La Celestina

shouts, "Albricias, albricias, Elicia! Sempronio, Sempronio!" (1.56) ["Good news, Elicia! It's Sempronio!"]. She is in the middle of work, at the head of her bordello, and the skill upon which she must rely most is storytelling: she shouted her good news too soon. Elicia is with another man; and if Sempronio, her boyfriend, finds out, there will be hell to pay. Celestina thinks quickly: she coaches Elicia to tell the man she's with that her cousin has shown up; when she comes downstairs and sees Sempronio, Elicia pretends that she's mad at him for not coming by for three days and that the noise upstairs is one of her new lovers. Celestina tells Sempronio that Elicia is just crazy with anger and puts a flourish on her fiction by telling him that the noise upstairs comes from some girl, entrusted to her by a fat friar, whose advent she awaits (1.56–57). Thus Elicia deceives Sempronio with the truth; Celestina fools him with a salacious lie; and the two of them can begin to negotiate the business of Calisto and Melibea.

One thing is clear from their brief encounter. Sex, fiction, and money are intertwined in this text. But that was evident already in Sempronio's initial description of Celestina.

Before he gives her a proper name, the first thing that Sempronio calls Celestina is "una vieja barbuda"(I.56). *Barbuda* is an augmentative form of the adjective *barbado/a*—bearded—so we are meeting a very long-bearded old woman. The beard in Spanish culture is a symbol of masculinity, power, and honor. It is a great insult, tantamount to (symbolic) castration, to tug at one's enemy's beard. Sempronio attaches, insultingly, an attribute of great masculine prestige to an old woman. It is true that after menopause some women have an increase in body hair, including facial hair.[34] So part of the aim of the description is to show that Celestina is not, to men, a desirable sex object, having outworn her use as one. But it is unlikely that the aim of this passage is clinically to describe an older woman. Rather, the primary effect is one of sexual confusion. The old woman has an attribute of a man. This makes her, in some readers' eyes, repulsive (*repugnante* is Menéndez y Pelayo's word).[35] But it also symbolically confers the phallus upon her. She may be ugly, but she is mighty.

The names that this old woman is called (*se dice*) illustrate her

[33]

power. First on Sempronio's list is Celestina. The most obvious etymology for this name is the Latin *caelestis,* "heavenly, celestial; divine, supernatural,"[36] a meaning that may initially seem to contradict her next epithet, *hechicera,* sorceress. But *celestial* and *supernatural* are words that connote the science of the *caelestia*, or heavenly bodies, and their sometimes supernatural effect on worldly affairs: astrology. Alfonso X, el Sabio, had legitimized astrology as one of the seven liberal arts in his famous legal code, the *Siete partidas* (ley I, tit. xxiii, Part. 7).[37] But that was in 1263, and Alfonso the Wise was also the author of the laws protecting the rights of Jews to worship and live in peace.[38] His reign (1275–95) marks the period of greatest *convivencia*[39] in Spain.

But by the late fifteenth century, when Rojas was writing *Tragicomedia,* times had changed. Ferdinand and Isabella's accession to the throne in 1474 had unified Castile and Aragon; combined with their reconquest of the Muslim fiefs in the south, this made them the first monarchs of a unified Spain. The long-awaited political unification was followed by a growing desire for uniformity of faith. With the centralization of political power, the church was able to consolidate its own strength via the establishment of the Inquisition. In 1492, seven years before *Tragicomedia*'s first edition, the Catholic kings, at the urging of the Inquisition, permitted the expulsion of the Jews from all Spain:

> The king himself, in a letter that he sent to the Count of Aranda on the same day as the expulsion, explained the circumstances concisely: "The Holy Office of the Inquisition, seeing how some Christians are endangered by contact and communication with the Jews, has provided that the Jews be expelled from all our realms and territories, and has persuaded us to give our support and agreement to this, which we now do, because of our debts and obligations to the said Holy Office; and we do so despite the great harm to ourselves, seeking and preferring the salvation of souls above our own profit and that of individuals."[40]

Popular anti-Semitism, fears of the Reformation's rising tide, and the Inquisition's urge to power played upon Ferdinand and

Isabella's religious sincerity. The result was not only the loss of the Jews, whom Henry Kamen calls "a significant, prosperous, and integral part of society,"[41] but also the loss of *convivencia*. The elastic cultural self-concept that had privileged Catholicism yet permitted difference was fast solidifying. Jews, the symbols of difference, suffered first. Later, so did other non-Christian people and philosophies, among them astrology. Henry Charles Lea points out:

All divination which pretended to reveal the future had long been regarded as heretical, on account of its denial of human free-will and its assertion of fate. This applied especially to astrology, with its array of horoscopes and its assumption that the destinies of men were ruled by the stars. . . . In spite of [this] the profession of astrology continued to flourish unchecked, and astrologers were indispensable in the courts of princes and prelates.[42]

Inquisitorial theologians continued to publish objections,[43] but "[t]hese condemnations however were purely academical; the old prohibitions had become obsolete; belief in the science was almost universal; it was not only openly practiced but openly taught."[44] For example, until 1583, when the teaching of astrology was suppressed, the University of Salamanca was the discipline's stronghold in Spain.[45] The existence of the essentially heretical faculty of astrology in a church-controlled university is the historical source for an allegorical meaning of Celestina's name. Rojas, an alumnus of the university,[46] must have been acquainted with the noisy accusations hurled by theologians at a discipline that was heretical yet thought so integral to humanity's well-being that as late as 1570 the Cortes petitioned that no medical doctors be graduated without a *bachiller* in astrology.[47] Theologically, and thus implicitly, morally despicable, astrology was nevertheless needed in order to understand human life. Celestina serves as an emblematic name for someone who is, and whose science is, heretical yet necessary.

Unlike astrology, which, however heretical, was immune to

harmful persecution for centuries because it was enfranchised at the university, a bastion of established power, the knowledge of an *hechicera* came from folk and pagan practices and beliefs. In the absence of an organized, male-dominated medical profession, folk medicine and its female practitioners prevailed. But the formulas and rituals of these healers were not always in conformity with Christian practice; for this reason, the Inquisition attacked and tried to expunge *hechicería* from Spain. This occurred in spite of the fact that (like belief in astrology) use of the *hechicera's* powers was endemic—but she served not nobles and princes but more common folk, and she was without institutional defense.

Thomas S. Szasz, M.D., in *The Manufacture of Madness,* provides a concise and thorough description of the situation of healers in Celestina's epoch:

Since secular healing had been forbidden by the Church, it could be practiced only by social outcasts: Jews or witches. As [English historian] Pennethorne Hughes points out, "Jews were branded as usurers because no one but a Jew was permitted to lend money under the medieval system, and they were allowed few other professions. In the same way, witches had largely a monopoly of the powers of healing—the dual powers of healing and harming—because of the medieval injunction against medicine.[48]

With the coming of renaissance humanism, the old prohibitions against secular medicine began to lift—but trained physicians, whose cures were often less effective than folk medicine's (perhaps this explains the need for astrology—it provides some connection to magic and popular wisdom), still served only the rich. Szasz quotes Jules Michelet's classic commentary:

The sorceress interpreted and administered the magic rites of healing (to control disease) and of personal influence (to control malefactors). "For a thousand years . . . the people had one healer and one only—the Sorceress. Emperors and kings and popes, and the richest barons, had sundry Doctors of Salerno, or Moorish and Jewish physicians; but the main body of every State, the whole world, we may say, consulted

no one but the *Saga,* the *Wise Woman.*" Indeed, the good witch was not only physician, but astrologer, necromancer, prophet, and sorceress as well. The study of anatomy, long prohibited by the Church, began with her; this is why she was accused of robbing graves and selling children to the Devil. The study of poisons, of chemistry and pharmacology, began with her as well.[49]

Among other *hechicera* traits, the text documents Celestina's grave-robbing and pharmacological skills (7.122–23; 1.60–62). She is firmly within the wise woman tradition; as such, like the Spanish wise women described by Kamen, she

could offer medicinal ointments, find lost objects, heal wounded animals, help a girl to win the affections of her loved one. Cures might take the form of potions, charms, spells or simply advice. It was a subculture that coexisted with and did not try to subvert official Catholicism, though in certain New Christian areas the Christian content of the spells was doubtful.[50]

Celestina is one of the combination witch-healer-midwives who made cosmetics and medicines, knew herbs and delivered babies, arranged romances and repaired their effects—in other words, who had control over the corporeal side of love and life for the folk of Western Europe until the establishment of patriarchal medicine in the Enlightenment. The power of these women over the basic functions of life exceeded (in practical terms) even the church's. They were often old and unmarried—that is, neither sexually nor economically under the direct control of a man. Both Lea, a traditional historian, and Mary Daly, a radical feminist philosopher, concur that eventually their numbers, power, and the evidently (if unintentionally) subversive nature of their work combined with epistemological and economic crises and led to popular paranoia and their extermination: the *gynocide* of the witch-craze.[51]

Being a wise woman means being between—between sexes (*una vieja barbuda*); between classes (women of all estates require

her services, and she herself might be prosperous although despised); between the oppositions set up by the culture: a woman, but wise; a woman, but powerful; a woman, but neither sexually desirable nor marriageable and therefore falling between the cracks in the patriarchal platform.

This lack of submission to the rigidities of orthodox culture is what makes Celestina evil. In his 1611 *Tesoro de la lengua castellana o española*, Sebastián de Covarrubias's entry on her reads:

Celestina. Nombre de una mala vieja, que le dió a la tragicomedia española tan celebrada. Díxose assí *quasi Scelestina, a scelere*, por ser malvada alcahueta embustidora. Y todas las demás personas de aquella obra tienen nombre apropiados a sus calidades.[52]

[Celestina. Name of an evil old woman, which is given to the celebrated Spanish tragicomedy. Thus, almost *Scelestina*, from *scelere*, because she is an evil and deceiving go-between. And all the other characters of that work have names appropriate to their qualities.]

Scelus, -eris (n.) means "wicked deed, crime, wickedness; calamity; scoundrel, criminal." One wonders whether Covarrubias would apply the same etymology to Celestinus, the name of several popes. One also wonders why a definition *quasi* is provided, when the word is clearly immediately derived from *caelestis*. The problem is, needless to say, one of interpretation. Covarrubias's two assumptions—first, that "all the characters of the work have a name appropriate to their qualities"; and second, that Celestina is "a fiendish and deceiving go-between"—make it necessary for him to find a word that connotes those qualities in his etymology of her name. If she is supernatural and heavenly, then she is so in an unorthodox way, and is a heretic, a criminal.

But, in fact, Celestina is not essentially evil. To call her evil is like punishing prostitutes for selling their wares—what fault there may be lies as much with the person who buys them, whose own desires make the sale possible. In his article, "Celestina: The Aging Prostitute as Witch,"[53] Javier Herrero provides an example

of the displacing of blame and projection of evil from its perpetrators to those who serve them:

> Celestina does not spare the Church itself; she makes of the holy retreat of friars and nuns her marketplace.... Such is her authority that she commands the most abject servitude in the house of God itself: she has, in fact, transformed it into a brothel! (36, 38)

Celestina is in church because that is where the customers are. It is their lust, and not only hers, that is sacrilegious. More than an agent of evil, Celestina is a scapegoat, a screen upon which the guilt and fear of others are projected. These projections are easily focused upon her because her behavior is heretical; "it derives partly from pre-Christian, pagan sources, . . . she readily appears as a strange and bizarre figure, . . ."[54] she is powerful and outside authority. Her art involves

> an appeal to a power other than that of God, a presumptuous attempt to compel by human arts what could be granted or denied only by Divine Will. If any magical rite succeeded, it could only be by the help of devils, and whoever sought to do anything, even good, by such means must be God's enemy. Healing charms were condemned no less than darker sorceries.... However, by aiding the weak, the white witch tended to undermine the established hierarchies of dominance—of priest over penitent, lord over peasant, man over woman. Herein lay the principal threat of the witch to the Church.[55]

The main way that Celestina subverts "the established hierarchy of dominance . . . of . . . man over woman" is through her willingness to encourage sexual intercourse outside matrimony—thus avoiding the legitimizing and controlling power of the church and the economic influence of the patriarchal family.[56] These alliances occur at the level of prostitution as well as at that of freely elected mutual love affairs. Thus, a woman like Celestina comes to incarnate, via the mechanism of projection, illicit desire, with the result that the authors of the great manual of witch-hunters, *Malleus Maleficarum* (1484), Heinrich Kramer and James

Sprenger, can write that "all witchcraft comes from carnal lust, which is in women insatiable."[57] If all they want to do is have sex, and if it is true, again according to *Malleus*, "that adulterous drabs and whores are chiefly given to witchcraft," it is hard to understand why witches were so often accused of making men's penises disappear and evaporate, or why they would want to make men impotent and incapable of performing the act that they so libidinously crave. Kramer and Sprenger conclude that the aim of witches in this matter is to undermine the sacrament of matrimony (55–57), that is, to undermine simultaneously church and patriarchy. Their work causes "every opportunity for adultery when the husband is able to copulate with other women but not with his own wife; and similarly the wife also has to seek other lovers" (55). Impotence caused by witchcraft attacks matrimony at its foundation, even providing grounds for annulment (57).

Celestina as *hechicera* moves beyond and encourages movement beyond recognizable limits and boundaries: she creates the possibility of a vulva beyond patriarchal jurisdiction: she is what has been called a witch. Gilman has stated that her incessant movement is Celestina's essential characteristic:[58] despite her advanced age, she moves easily across the impossible boundaries that demarcate spheres of Spanish life in the epoch of the Catholic kings. People believed that witches flew effortlessly by night, that they were able to be in more than one place at one time;[59] their indefinability and freedom from boundaries are part of their great menace: they cannot be controlled, fixed in one place, named, by anyone except themselves. They alone decide who they are, how they act, what they mean; they name themselves. The interpretations they give about themselves are valid only as long as they authorize them and are changeable at will. A witch can be anything she wants to be. Celestina's easy omnipresence is linked to this witch's characteristic.

In the universe of *Tragicomedia*, Celestina is murdered not only because she is greedy for gold,[60] but because she is a witchy woman—she does not accept Sempronio's and Pármeno's restric-

Hymen and Text in La Celestina

tions upon her movement any more than she accepts the lovers' assumption that the garden wall between Melibea and Calisto is insurmountable, or that age should deprive her of whatever sexual enjoyment she can sense, or that because Areusa is a woman she may not revel in the sight and feel of her. (In this episode [7.127] Celestina sexually fondles Areusa, who had complained of cramps, to the point that Areusa must ask her to move her hand "más arriba, sobre el estómago" ["higher up, above my stomach"]. Celestina responds with a voyeuristic paean to Areusa's charms, finally exclaiming that she wishes she were a man so that she could enjoy Areusa. Celestina's lesbianism has been bowdlerized by critical inattention.) She is indifferent to the boundaries set up to control and mark her, whether they be architectural, social, or sexual. Many critics find Celestina repulsively insatiable and perverse and thus the agent of unmitigated evil in the text. Possibly this is because, just as one lover is not enough to satisfy an insatiable woman, one critic's interpretation is not enough for a text that requires multiple meanings.

One way that Celestina moves across boundaries is through her skills as *hechicera;* almost everyone requires her healing services, with the result that she has access to the intimate lives and bodies of people from many classes and life situations. But another of her trades gains her entrance to even more sensitive areas. Her expertise as a seamstress allows her to tangle with the very fabric of society and the text, in a surprising way. Her stitching brings together subversive functions of sex and fiction.

On the level of plot, Celestina's stitching is subversive because she operates her brothel under cover of a sewing school:

> Ella tenía seis oficios, conviene a saber: labrandera, perfumera, maestra de hacer afeites y de hacer virgos, alcahueta y un poco hechicera. Era el primer oficio cobertura de los otros, so color del cual muchas mozas de estas sirvientas entraban en su casa a labrarse y a labrar camisas y gorgueras y otras muchas cosas; . . . Asaz era amiga de estudiantes y despenseros y mozos de abades; a éstos vendía ella aquella sangre inocente de las cuitadillas, la cual ligeramente aventuraban en esfuerzo de la restitución que ella les prometía. (1.60)

[She had six offices, it is useful to know: embroiderer, perfumer, master of making cosmetics and virgins, go-between and a little bit of a witch. The first occupation was a cover for the others, so that many servant girls used to go to her house to stitch themselves and to stitch shirts and ruffles and many other things; . . . As such she was the friend of students and alms-distributors and abbots' pages; to these she sold the innocent blood of poor little things, which they lightly risked because of the restitution that she promised them.]

The sexual activity of the young women is bordered on one side with the stitching of the sewing school and on the other with the stitching of "the restitution" that Celestina promises them after they sell their signifying virgin blood: the mending of their hymens. The vocabulary of stitching by 1499 in Spain and elsewhere already had acquired the strong sexual double entendres that are a mainstay of contemporary bawdy literature.[61] Generally, the tools of sewing are symbols of the phallic or vulval parts they most obviously resemble.[62] It is interesting, though, that the needle (penis) has a hole (its eye) which is vulval, through which thread (penis) seeks to pass.[63] These comic poems have the phallus in stitches, immobilized in the weave of its own fabrication: its insistence on clearly defined borders paradoxically calls its own identity as a phallus into question. To stitch is to bring together, which is the office of a go-between. It is to have sex: the obscene metaphors of the time make that amply clear. To stitch is also to remedy the results of bringing together and having sex: to sew up the hymen so that the whole process can be repeated under the law. But sealing up the lips, making them silent and conforming, at the same time makes them tell a lie, and that silent fiction undermines the law that it seemingly serves.

After naming her an *hechicera,* Sempronio says of Celestina,

"entiendo que pasan de cinco mil virgos los que se han hecho y deshecho por su autoridad en esta ciudad" (1.56)

["I hear that by her authority more than five thousand virgins have been made and unmade in this city."]

"Hacer virgos" means to mend the hymen of a woman who has had sexual intercourse so that it appears to her next sexual partner that she has not—that is, to make it seem that she is a virgin, *virgo intacta*. Pármeno, the son of Celestina's departed mentor, partner, and friend, lists some of her various means for achieving this effect:

"Esto de los virgos unos hacía de vejiga y otros curaba de punto. Tenía en un tabladillo, en una cajuela pintada, unas agujas delgadas de pellejeros e hilos de seda encerados, y colgados allí raíces de hojaplasma y fuste sanguino, cebolla albarrana y cepacaballo; hacía con esto maravillas: que, cuando vino por aquí el embajador francés, tres veces vendió por virgen una criada que tenía. . . . Y remediaba por caridad muchas huérfanas y erradas que se encomendaban a ella." (1.62)

["She made some virgins using bits of bladder, and others she fixed with the stitch. In a cabinet, in a painted box, she had some thin wigmaker's needles and waxed thread, and hanging there roots of plants and their membranes; with this she worked marvels, so that, when the French ambassador came here, three times she sold one of her maids to him as a virgin. . . . And, out of charity, she remedied many orphan and stray girls who had been entrusted to her."]

More than five thousand virgins have been made and unmade by her authority in this city and by her skill with her tools. Using blood-filled bladders, wig-makers' needles, waxed silk thread, and vegetable membranes, she works wonders such that she could thrice sell one of her servants as a virgin to the visiting French ambassador. Thus, she makes money by selling fiction: she represents virginity well enough to make a living by it and to save the lives of some unfortunate women who might be destroyed by society if their illegal sexual activity were known.

Examining Covarrubias's entry *virgen* in his *Tesoro de la lenqua* illustrates the degree to which Celestina's authority subverts established authority:

VIRGEN. *Latine virgo, puella intacta, a vividiori, id est validiori aetate appellata est.* Por otro nombre la llamamos donzella; deste estado y de

la virginidad y su castidad avía mucho que dezir, pero es lugar común, y assí me contento con lo dicho, y con remitir al lector curioso a un emblema mío, cuya figura es una açucena rodeada de un seto rompido y ella destroncada, con la letra: *Nulla reparabilis arte*. Virginidad, cosa pertinente a los vírgenes.[64]

[From the Latin virgin, an intact girl, by a livelier, that is a more robust age she is called. By another name we call her damsel; of this state of virginity and its chastity much has been said, but it's all a commonplace, and thus I content myself with the aforesaid, and with recommending to the curious reader an emblem of mine, whose figure is a lily surrounded by a broken fence [or hedge], and she [the lily] uprooted, with the motto: *Not reparable by any art*. Virginity, thing pertinent to virgins.]

Circumlocution characterizes Covarrubias's definition: there is a lot to say about this, but it's a commonplace so I am content with what I have said. But he is not at all content with what he has stated; rather, he continues with an illustration, referring the "curious" reader to an emblem of his, which shows an uprooted lily surrounded by a broken fence or hedge, with the motto "Not reparable by any art." The emblem of virginity is not virginity; instead, it is a warning that has clearly come too late, or a threat; the lily is already uprooted. Some boundary has been transgressed, and a sign inverted; that is virginity? What is more, this complexity cannot be understood without authoritative interpretation—thus, the explanatory motto in Latin.

But the textual undermining that accompanies the state of (dubious) virginity seems to undo Covarrubias' syntax, wrapping it in ambiguities. First, there are multiple layers of communication: the dictionary entry *Virgin,* which requires definition; the succeeding non-definition and refusal to say more; the *figura,* which says more; the motto which, read and interpreted, writes over the *figura.*

The *figura* is transformed in its description. First, there is "una açucena rodeada de un seto"—a lily surrounded by a fence. But the *seto* is *rompido* (ant., broken); so how can the lily be surrounded? There is a gap in what surrounds it. "Un seto rompido

Hymen and Text in La Celestina

y ella destroncada"—a broken fence and she [the lily] uprooted; the syntax of the entry is constructed such that the living organism is destroyed by the process of definition and representation in writing; the lily, because of the signification assigned it, is ruined. Literally, the phrase says, "a lily surrounded by a fence broken and her uprooted." The ambiguity of the syntax emphasizes the fact that the lily is surrounded by the meanings of the broken fence and uprootedness; it is these emblems of transgression that give the lily the symbolic meaning *virgen*. The acts of invasion and destruction are more evident than virginity is. Thus it seems that virginity is more a result of naming and defining than an essential quality—the lily is not a lily; it is, rather, a space to write in and over.

Covarrubias's motto hopes to define clearly and irrevocably: once the acts of breaking and uprooting have taken place, the results are "not reparable by any art." The moment is permanently fixed; there is no story to tell, no narrative flow. At least destruction has provided certainty: the hymen is broken; there is no virgin. The emblem in place to define *virgen* indicates "broken hymen" instead. Covarrubias's writing in the virgin space seeks certainty in the destruction of the object it tries to define and takes comfort in the authoritative affirmation that the hymen he has rent cannot be mended. But a hundred years earlier, *La Celestina*, and contemporaneously, the exemplary novel *La tía fingida*[65] challenge his claim. It is precisely art that confounds the meaning system virgin/not virgin, and on a broader level, the desire to fix meaning, to define the untold story in a text. Hymen mending sets the hymen free from definition because it confounds meaning. Stitching the hymen confuses the interpretive, naming function of phallic penetration; it makes ownership of meaning uncertain.

As Nancy K. Miller has noted, stitching and weaving have long been considered subversive to Western culture because their practitioners and the crafts themselves often go between sexual regulations and hierarchies, undermining them at the same time that they ratify them.[66] When Arachne weaves a superb tapestry

"against the classically theocentric balance of Athena's tapestry" in a "feminocentric protest" against the seduction and betrayal of mortal women by the gods, Athena punishes her by destroying her work—tearing her "countercultural account"—and throwing her out of the realm of language by turning her into a spider.[67] She may communicate in the act of making text, but not verbally.

Celestina's sewing operates like Arachne's weaving. Their forms of stitchery both challenge and maintain the established order that eventually undoes them and, with them, the narrative itself. In *Tragicomedia,* the act of stitching both advances the story (bringing together, rending, mending; going-between, opening, closing) and acts to untell it. Stitching up a torn hymen reweaves the text of its tearing; it annuls evidence of the phallus's action and renders that action irrelevant. Stitching the hymen makes indistinguishable the narrative moments of going-between, opening, and closing. The mended hymen is text written over; a pillar of signification topples; the lily lives despite the fact that the fence is broken. Hymen mending keeps the untold story untold, maintaining it in ambiguity and ambivalence. It does and undoes itself at the same time. It makes the acceptable (told) narrative possible precisely because of its complicity in the told narrative's economy and thus untells itself; but in that blatant negation, the hymen mender's power is known and felt. Her stitches hold together the possibility of something left to read and to tell, of narrative desire.

Some critics have noticed the influence of the interconnected activities of the go-between, the hymen, and the stitcher in the text. Their arguments tend to surface in conjunction with issues of gaps, spaces, or erasures in the text: precisely the spaces associated in chapter 2 with a vulva to be filled; or, that part of the text that indicates the untold story.

Go-betweens and hymens can be metaphorically indicative, as gaps and spaces can be narratologically indicative, of the untold story. Genette's example for paralipsis

> is the mysterious "girl-cousin" about whom we learn, when Marcel [Proust] gives Aunt Leonie's sofa to a go-between, that with her on

this same sofa he "experienced for the first time the sweets of love"; [?] . . . This little cousin on the sofa will be thus for us—to each age its own pleasures—analepsis on paralipsis.[68]

A gap, a girl-cousin, a go-between, and sexual initiation are wed together in Genette's note. The hymen is alluded to; the possibility of its being broken, hinted at; but it is unimportant enough to be unnamed in the absence of an unnamed character. Yet apparently this anonymity does not equal oblivion. The Proust quotation indicates one thing, something that Celestina learned long ago: lots of people care about the status of a hymen. Jacques Derrida does, too. Like Genette, he conflates the ideas of go-between, hymen, and sexual transgression. In this case the go-between is Stéphane Mallarmé, or actually Derrida acting as go-between writing about Mallarmé in "The Double Session": what he calls L'ENTRE-DEUX "MALLARMÉ."[69] Here, the hymen is by his prodigious etymologizing the tissue of undecidability in a text, its between; it is also "a little stitch," the element of text itself. The sexual transgression is Pierrot's mimed, frenetic, masturbatory suicide in *Pierrot Murderer of His Wife*,[70] a demonstration that marries laughter, murder, homoeroticism and rape.

To Derrida, what matters about the hymen in question is its incarnation of *entre*, between:

. . . if we replaced "hymen" by "marriage" or "crime," "identity" or "difference," etc., the effect would be the same, the only loss being a certain economic condensation or accumulation, which has not gone unnoticed. It is the "between," whether it names fusion or separation, that thus carries all the force of the operation.[71]

But there are more losses than the critic wants to acknowledge. Another loss would be the loss of the metaphor to phallic transgression; metaphorically, a hymen in a vagina "carries all the force of the operation" of phallic analysis in a way that the alternatives that Derrida suggests do not. Both meanings of hymen—marriage and virginity—are constructs controlled by patriarchy

that objectify woman. And despite the confusion of sexual difference implicit in Pierrot's mime, the fact remains that he is a he; and only with a suspension of disbelief faithful to his need to control the hymen and the woman-idea to which it is attached can the critic forget that a phallus is running the show.

"If either one [marriage or non-consummation] *did* take place, there would be no hymen," insists Derrida.[72]

Jardine continues:

For Derrida, the hymen is the "absolute" in undecidability; there is hymen (virginity) when there is no hymen (marriage or copulation); there is no hymen (virginity) when there is hymen (marriage or copulation).[73]

Both writers overlook the fact that there is always a hymen, that it is in its essence independent of marriage, penile penetration and the patriarchal meaning system *virginity:*

When you were born it was a thin membrane surrounding the vagina [*sic*] opening, partially blocking it but almost never covering the opening completely. Hymens come in widely varying sizes and shapes. For most women the hymen stretches easily. Even after being stretched, little folds of hymen tissue remain.[74]

So it seems that marriage and penetration are irrelevant to the hymen *qua* hymen. It names neither fusion nor separation. Most important, regardless of metaphorical or physical refiguring, it still *is:* If either one takes place, there is still a body—"little folds of hymen tissue remain"—that exists outside whatever interpretive construct. In other words, the importance of the tissue-text called hymen to marriage and virginity is made up, a fiction. In addition, it is a fiction that untells another story, that of the hymen that was and is, regardless of phallic action: the possibility of woman as subject. Folds of hymen text remain, pages of an untold story. The

Hymen and Text in La Celestina

history of literature . . . if it has any meaning, is governed in its entirety by the value of truth and by a certain relation, inscribed in the hymen in question, *between* literature and truth.[75]

"Inscribed in the hymen" (according to Derrida one of the meanings of *hymen* is *text*) means "written over the text," a story told over another story, untelling it. This inscribing, this scratching in, depends upon the use of some kind of pen, without which its process would be impossible. Why this insistence that the hymen be written over, broken? It is already open (if it were not, menstrual blood could not pass through; the hymen fiction again rewrites anatomy for metaphor). It is already text: but perhaps it is problematic because it has no meaning, or no meaning congruent with phallic confabulation. Because it is indifferent to that fiction and to the economy that the fiction represents, some invented meaning, "a certain relation" must be inscribed in it because any story it might tell, or even its silence, speaks neither for, with, nor about the phallus. And so the hymen is fictionalized and made to tell the story of the phallus marking woman as object; stories of marriage/copulation or virginity, or both: but never neither—that is, never the story of a hymen indifferent to the phallus.

The hymen is not between, at least not in the sense of being between oppositions of open/closed, or virginal/penetrated. It is not part of the phallic equation, whose terms are irrelevant to it. Perhaps that is one of the reasons why the word *himen* does not appear in *La Celestina*. The text is not shy about the obscene, and there are references to Celestina's trade of making and unmaking virgins, but the hymen is never named. The female body is seen not as a subject but rather as an object of interpretation.

Celestina "hace y deshace virgos," and the tools of her craft are carefully delineated in the text. That is her trade, the way she makes money and acquires prestige. The cover operation for her illicit activities is her impromptu sewing and domestics school. Women come to her in order to learn how to sew; their stitching works in both the textile and sexual media alluded to earlier. The

women Celestina supervises in her brothel work for her only part time; they keep their other jobs as servants and earn while they learn at Celestina's.

Celestina is adept at all her crafts, but is "maestra de hacer afeites y de hacer virgos"—a master and teacher of making makeup and of making virgins. The two crafts are not paired arbitrarily. They are linked because they are strategies that women use to fictionalize their bodies, to protect themselves, to challenge the rewritings imposed on them by the dominant sexual economy. Makeup works to play into fantasies of what makes a woman desirable, so that the woman can gain power through attracting and marrying a man, and thus perhaps reach some position of security. She rewrites herself so that he is willing to read her. The makeup covers who she is underneath; it paints the label *object* on a subject. But it can be put on and removed at will.

Within the limitations imposed by a strictly regulated society, makeup permits women the chance to make up their own stories. Similarly, in a literal way, one has one's hymen mended for cosmetic reasons: to cover up what is perceived as a defect, to conceal the truth about oneself, to make one's body tell a story in order to protect oneself and to survive. It does what Scheherezade did, but without words.

Because of the crafts that Celestina practices and teaches, she and the women who work with her subvert the economic order by earning their own money; they subvert the social order by this independence, which puts them beyond the economic and legal constraints implicit in marriage;[76] they subvert the sexual order by exercising control over their own bodies, again, outside the domain of family and marriage. Textually, hymen mending is subversive because it releases femininity from meanings irrelevant to it. It negates the reader's interpretive efforts by robbing his sign system of meaning. Social structures and the structure of *La Celestina* are balanced upon the thesis that if a woman bleeds when a man penetrates her, she is a virgin. The historical and literary fact of hymen mending unsettles this balance: a whore can bleed like a pristine maid. Meaning, the power conferred by

Hymen and Text in La Celestina

the control of meaning, and the labels meaning assigns are unseated by uncertainty and by simultaneous multiple meaning: Was I the first? Is she mine? Can I give her my name? Only her hymen mender knows for sure. The hymen is not undecidable, that is, the sign of either virginity or marriage or both; it is neither—it is simply a membrane-text, before, during, after, and irrespective of phallic narrative or interpretive action. All it tells is that it is and that it has nothing to do with the stories told about it. A hymen called either marriage or virginity or both is a told story. The missing meaning that is the stitched hymen is an untold story: a woman's thread, stitched and pulled ("hecho y deshecho") through the told patriarchal narrative, irrespective of restrictive meaning. The process is like Penelope's weaving and unweaving, which prevents her hymen (her marriage, the ownership of her body) from being decided against her will.

While Homer provides a literary canonical archetype for the woman who protects herself from objectifying definition by text-making and unmaking, Freud offers, paradoxically, an anthropological and psychological one. To answer the question, who is the person who, by inventing the craft in prehistory, made it possible for Celestina to learn how to stitch, Freud responds that it was a woman, who, moved by shame at her lack of a penis, imitated the example of the pubic hair that seemed to hide her defect and invented the techniques of plaiting and weaving.[77] In other words, an unknown woman whose textile attempts to confound the symbolic dominance of the phallus. In *La Celestina*, this unknown woman at the origin of stitching is Claudina,[78] Celestina's best friend and mentor, who died an unmentionable death for unmentionable crimes (7.125). Pleberio's lament for himself and Melibea at the end of the story (21.232–36) is sad and painful, but Celestina's pragmatic grief for Claudina is an equally moving though unsentimental eulogy to a soul mate and colleague (7.122–25).

Between us the house has no wall, the clearing no enclosure, language no circularity. When you kiss me the world grows so large that the

horizon itself disappears. Are we unsatisfied? Yes, if that means we are never finished. If our pleasure consists in moving, being moved, endlessly. Always in motion: openness is never spent nor sated.[79]

These sentences describe Celestina and Claudina's joint narrative activity in the text. Luce Irigaray originally wrote them, though, to describe the communion of the vulva with itself, without regard to phallocentric sexual economy; that is, not as object or fragmented anatomy ("Neither one nor two"),[80] but as whole between. There is, then, a triangular connection of Celestina, Claudina and the untold in the text. This connection can be found via the pronouns *us* and *you* in the Irigaray quotation. For Celestina, *us* and *you,* neither one nor two, is herself and Claudina. Celestina says of her:

"Su madre e yo, uña y carne; de ella aprendí todo lo mejor que sé de mi oficio." (3.81)

["His mother and I, fingernail and finger; from her I learned all the best I know of my profession."]

"Como uña y carne" is a simile for closeness at least as old in Spanish as *Poema de mío Cid*. Interestingly, in that nationalistic martial epic, the nail is torn from the flesh when Doña Jimena's husband the Cid leaves her in a monastery just before he rides off into exile.[81] But in *Tragicomedia,* despite Claudina's death, time and distance have no effect on her and Celestina's intimacy. The simile "como uña y carne," deprived of a comparative (there is neither *like* nor *as* in Celestina's statement), gains the strength of metonymy. It is stronger for its lack. There is no verb, no time sense in her description; the two women are as perpetually indivisible (in their nevertheless interwoven individuality) as the word *fingernail* is in English, although in Spanish the unity of phrase and signified, matched with different nouns joined by a conjunction in the signifier, perhaps more fully communicates the "neither one nor two" of the imaged relationship.

Like the lips Irigaray describes, the "uña y carne" are a fleshy

Hymen and Text in La Celestina

organ that touches itself everywhere, whose edges are indistinguishable from intersections. Irigaray's lips are said to speak, but the "uña y carne" are silent. They make meaning through action. They work. Intimacy and work are the things that Celestina weds in her first emphatic description of herself and Claudina. The work they do is intimate, in the sense (common to Spanish and English) of having to do with love and genitalia. It has to do with the vulva: they stitch.

This is an untold story of *Tragicomedia:* it is linked to the woman's body that exists outside the interpretive construct, the story of Claudina, Celestina's authority. The supernarrative, *Tragicomedia de Calisto y Melibea,* their orthodox love story and its moralizing support of the dominant order, can take place only because Claudina existed at one time and taught Celestina what she knows. The arcane knowledge that makes this story move (Celestina's work is necessary to bring Calisto and Melibea together) comes from Claudina, who, though barely mentioned, missing a voice of her own, and punished by death for her deviance before the action begins, is the narrative's *sine qua non.*

She is as marginal as can be in her society, a single woman taken and punished at least five times by *la justicia* (7.124) and at least once accused of witchcraft: "Y aun la una le levantaron que era bruja, . . ." (7.124) ["And once they even charged her with being a witch . . ."]. Witch or not, Claudina was certainly a wise woman and met a fate common to them. She was living dangerously, on the surface as a *partera,* a midwife, but practicing the same trades she passed on to Celestina (7.123)—those of *hechicera* and *alcahueta*—and employing all the techniques implied by those offices. Celestina, we remember, says that Claudina taught her everything she knows. These two women, then, stitch not in competition, like Athena and Arachne, but together, and because of that activity achieve some narrative expression on the reverse of the text that they weave for the dominant order.

On the level of narratology, the gap that is the untold story of their friendship and of Claudina's life must not be filled; if it were, both the dominant narrative (*Tragicomedia*) and the implicit

documentation of their unorthodox friendship would be lost. Their story cannot be told because it has nothing to do with *Tragicomedia;* they are permitted in the narrative only insofar as they are useful to its propagation. The situation is similar to the situation of hymen menders. Their work, though necessary to the smooth functioning of societal valorization of honor and virginity, must be negated, pushed offstage into the obscene; their work is aware of and documents a side of the dominant culture that that culture seeks to repress because that side does not conform with its idealized self-image. The necessary service that hymen mending provides the dominant order is that it permits that order to lie to itself about itself; to have its cake and eat it, too; to make of the two (or more) stories that it is telling only one, and that the acceptable one: when the hymen is stitched up, the participating man and woman, because of their literal interpretations of the signifiers *closed hymen* and *bleeding,* can free themselves of the unbearable terms *fornicator* and *whore.* Textually, from the dominant perspective (parallel to Derrida's), the stitched hymen is the emblem of censorship and of the erasure of difference, confirming the fictive power of the phallus, letting it determine the story as it wills.

But, ironically, hymen menders and their weaving are what make possible another story. Because of their need for go-betweens and hymen menders, the agonists of *Tragicomedia de Calisto y Melibea* must make room for *La Celestina.* When we examine the text for what it represses about the character who has become so identified with it that it takes her name, we can follow her weave from the string she uses to bewitch Melibea to the silk thread with which she mends hymens,[82] and that thread leads us to Claudina, a repressed and almost unutterable alter ego who signals from beyond the grave that there is an untold story on the reverse of this text.

For telling her own story, blatantly, publicly—she accepted even misfortune as long as it would broaden her reputation ("Que mil veces le oía decir; si me quebré el pie, fue por bien, porque soy más conocida que antes" (7.125) ["I heard her say it a thou-

Hymen and Text in La Celestina

sand times: If I break my foot, so much the better, because I'm better known on account of it"])—Claudina was eventually killed. Like her, Celestina, too, must pay for her difference and independence with death. Pármeno, to whom she has told her untellable story, is an accomplice to her murder. This is despite the fact that, in the fight that takes place immediately before they kill her, it is possible that Pármeno is just going along with Sempronio out of a need to bluster.[83] Originally he is visiting Celestina only to eat and sleep, not to get money, that is, until Sempronio goads his greed (7.178–79). At any rate, he intends at that moment not to kill her, only to scare her into handing over some of the loot. But when she reminds him that she has told him part of her (and, paradoxically, his) untold story, the story of his mother the witch (children of accused witches were often punished with their mothers because witches were thought to occur in families, the demonic tradition being passed down through generations), he explodes in anger at even the mention of the unmentionable and *himself* produces the sentence of death (7.182–83). When Pármeno hears something about himself that he does not want to acknowledge, he silences the source of the story with death. Ironically, killing that disturbing source also brings about his own death. Sosia, a character introduced in the latter part of the work, says:

—Señor, la causa de su muerte publicaba el cruel verdugo a voces, diciendo; "Manda la justicia que mueran los violentos matadores." (8.187)

["Sir, the cruel hangman loudly announced the cause of their death, saying; 'Justice commands that violent murderers must die.' "]

In a similar way, when the narrative kills off Celestina, it, too, dies, although this happens more quickly in the 1499 version (*Comedia*) than in the 1502 (*Tragicomedia*). With Celestina dead, and the untold story's catalytic action stopped, the narrative grinds to a halt. The rapid movement and suspense characteristic of the text before her death are snipped off with her life thread because,

[55]

as Lucrecia mourns, "... No hay quien ponga virgos, que ya es muerta Celestina" (16.205) ["... There is no one to make virgins, now that Celestina is dead"].

The subversive confusion of meaning ceases when Celestina is killed and can no longer create fictional virgins, weave her fictive hymen text. The inevitable result of this fact is that Melibea's hymen is irrevocably decided. She has sex with Calisto (16.204–5) and there is no one to help them slip through the rigidities of meaning that the dominant textual order imposes on that act. With Celestina's death, difference in the text and meaning outside or beyond the dominant discourse become inaccesible. Calisto and Melibea both die, *post errorem,* because their error cannot be written over. The threads that held them up to move are cut, and both of them fall to their deaths. Their ability to move, to be in the process of fiction, depended on a seamstress to make text for them. When her catalyzing action ceases to be, so do they.

Celestina is murdered because of the intolerable variation she is and propagates in the dominant textual order. She threatens to tell the untellable and must be silenced. She has a rival story to tell, one that must not be told because if it were it might take over the dominant narrative. And yet, the narrative space of this untold story must not be stopped, filled in, because its unbounded, unknowable, unacceptable vacancy is, precisely, the space in reaction to which the dominant narrative feels forced to define itself, to which it reacts as to a rebellious reflection, creating itself in order to cover up that hole, that frightening other space.

CHAPTER 4

Marriage, Motherhood, and Deviance in *El casamiento engañoso/Coloquio de los perros*

The second chapter of this study tries to elucidate a theory of gaps in narrative and of the reader's approaches and responses to them. The discussion of *Tragicomedia de Calisto y Melibea* in the third chapter shows how the presence of these gaps, as untold stories, both subverts and supports the dominant narrative in which the untold story exists.

This fourth chapter examines the untold stories attached to two deviant women characters in Miguel de Cervantes's *Novela del casamiento engañoso* [*The Deceitful Marriage*] and *Coloquio de los perros* [*Colloquy of the Dogs*].[1] These characters—the so-called prostitute of *Casamiento*, doña Estefanía, and the alleged witch of *Coloquio*, Cañizares, are influenced by the characterization of Celestina.[2] In the double work that is *Casamiento/Coloquio*, the Celestinesque character splits into two in a way that reflects the structure of the text. As the two works are structurally united and mutually dependent yet able to stand alone in their individual exemplarity,[3] so are doña Estefanía and Cañizares interconnected in the production and undermining of the text. The two texts

[57]

reciprocally generate each other,[4] and here, as in *Celestina,* untold stories that manifest themselves through the characterization of socially unacceptable females are related to the production of the dominant narrative.

The Wife

Casamiento begins when the ensign Campuzano, who is taking a cure for syphilis in the Hospital of the Resurrection in Valladolid, runs across an old acquaintance, the licentiate Peralta. The two settle down to eat as Campuzano relates the misfortune that brought him to such a state: how he married doña Estefanía, a woman who convinced him of her financial security, only for him to discover that she was pretending to own a home and estate that really belonged to another woman. Enraged at this revelation, Campuzano rushes to get an explanation from his wife. But he finds only a friend of hers, who tells him that, in addition to lying to him about her bank account, she has fled with another man and a trunkful of the ensign's belongings, among them some gold chains that he had told Estefanía were worth more than two thousand ducats (226). Peralta expresses shock at this larceny. But instead of graciously receiving his sympathy, Campuzano admits that "no es todo oro lo que reluce" (233) ["not all that shines is gold"]—that his fortune in jewelry was all dross, that he in his turn had lied to doña Estefanía in order to impress her with a fictitious fortune.

Doña Estefanía's estate was an illusion and Campuzano's treasure the product of "alquimia" (233) [alchemy]; she disappears from the narrative, he is at the end, penniless, sick, and bald with the pox. The only positive result to come out of the experience for him is that over the course of two nights, while recovering in his bed from strenuous treatments for the syphilis he caught from her, he had the good fortune to overhear the conversation of two watchdogs, who for those two evenings were inexplicably yet apparently miraculously bestowed with the gift of speech. Campuzano has written down, from memory, the first night's

conversation, which he hands to a skeptical but amused Peralta. The ensign stretches out on a cot, and the licentiate opens the manuscript. *Coloquio* starts immediately; one dog tells the story of his life. When the sun comes up, the dogs quiet down. Peralta's reading of *Coloquio* is over; simultaneously the ensign wakes up. Peralta tells him that even if *Coloquio* is made up—"aunque . . . sea fingido" (321)—it is so well written that the ensign should proceed with the second one. They leave aside the question of the event's authenticity, and the narrative ends.

As his use of *Casamiento* as a central theme and title word would indicate, Cervantes was often preoccupied with marriage and its moral and social meanings in the Spain of the Counter-Reformation. In his epoch, traditional structures were under stress as a result of economic crises and opportunities caused by imperialism in the New World; additionally, the sweep of Protestantism in Europe provoked ideological crises. These concerns affected marriage as a social contract and as a religious institution. Cervantes absorbed the moderate solutions proposed by Desiderius Erasmus, whose *Enchiridion militis christiani* and *Colloquia,* in Spanish translations,[5] were extremely influential in Spain.

But the concerns of *Casamiento/Coloquio* are not exclusively moral. A strong current of metaliterary commentary runs through the work.[6] Somehow, a deceitful marriage produces discourse that moves outside the laws of nature. This chapter will leave aside the moral questions attached to the work and does not examine the effect of marriage on society or the mutations of the meaning of matrimony in the history of ideas but rather will demonstrate the coincidence of the theme of marriage with the untold story in a text.

Marriage, one might remember, is part of the meaning of hymen; and themes of virginity, consummation, and marriage attend the untold story in the text. These three (there may be more) functions of hymen tend to occur together, in the same way that Celestina's roles as hymen mender, healer, and go-between are mutually cooperative rather than divergent. For example, in the picaresque (a genre which catalyzes, to an extent,

Casamiento/Coloquio)[7] Roberto González-Echevarría places marriage in the context of uncontrolled sexual expression, sexual initiation, and conformity leading to redemption. After showing that the picaresque's protagonist is born out of, or between, wedlock, he demonstrates how matrimony affects writing in *Casamiento:*

> By focusing on the moment of marriage, Cervantes is calling attention to a crucial turning point in the picaresque: the end that "determines" its beginning. . . . In Cervantes's works marriage often appears as a dubious endeavor, which rarely ensures order and tranquility, though there are cases such as "Gitanilla" and "The Power of Blood" where it provides a happy closure. But in "The Deceitful Marriage" Cervantes is focusing on marriage as the end/beginning of a picaresque life, blowing it up, as it were, to study both the pícaro and the origin of his new vocation of writing. . . . The pure chance of [Campuzano's and Estefanía's] first encounter engenders an interlocking sequence of events that winds up with the dissolution of the marriage, a counterending in terms of the *comedia*, but also a step beyond the ending within the realm of the picaresque.
> And what is beyond the ending of the picaresque? The issue of the picaresque marriage is the elusive, ambiguous and inconclusive picaresque text. The pícaro "fathers" a picaresque novel.[8]

The implications of this argument are clear: Campuzano is able to write *Coloquio* only because he contracted syphilis because of his consummated marriage to doña Estefanía. The fruit of their union is disease and text—Campuzano gets to tell two stories (his own and the dogs').

But doña Estefanía is not permitted to speak for herself. She is curiously absent from the reproductive scenario staged by González-Echevarría, for example; the critic's pícaro is fathering a text without the commonly necessary agency of a mother. If anything, the structure of the reproductive metaphor would seem to argue that doña Estefanía impregnated Campuzano by means of disease, which erupted in the chancres that led him to the hospital:

—. . . salgo de aquel hospital, de sudar catorce cargas de bubas que me echó a cuestas una mujer que escogí por mía, que non debiera. (222)

["... I come from that hospital having sweated out fourteen eruptions of boils I caught from a woman whom I chose for my own, which I ought not to have done."]

The germ of the text is located in Estefanía's body. This seed consists of the space between oppositions that Estefanía represents. But that inversion of Aristotelian reproductive theory would make of doña Estefanía something other than a conventional woman. Nevertheless, this is precisely what the dominant narrative does: it makes the meaning of the *engaño* hinge on ascertaining whether or not doña Estefanía is a prostitute. The state of her body, in terms of dominant signifying systems, is made crucial to the interpretation of the text. Since the text flirts with the possibility that she is a whore yet undermines that possibility with her later apparently "honorable" behavior, readers are left unsatisfied, still wondering, "Does she or doesn't she?"

The text makes the women appear to be prostitutes: "La una se puso a hablar con el Capitán en pie, arrimados a una ventana; y la otra se sentó en una silla junto a mí" [223] [One, standing, started to talk with the Captain, next to the window; and the other sat down in a chair next to me.] Yet the ensign insists on their "gentil parecer" [223] and goes on to elaborate on the modesty of the one who sits next to him. She wears a full veil which she refuses to remove. But her ring-studded hand suffices to arouse the ensign's desires. The two begin to bargain. The woman hints at beauty and wealth, and promises to unveil herself if the ensign comes to her house. The ensign offers mountains of gold in exchange. The ensign's careful language notwithstanding, this looks like a clear case of solicitation on the woman's part.[9]

In fact, in the text, it is the woman's language that is more "careful." She will not give in to his request for her unveiling— and when he pushes, her response is:

—No seais importuno; casa tengo; haced a un paje que me siga, que aunque yo soy más honrada de lo que promete esta respuesta, todavía, a trueco de ver si responde vuestra discreción a vuestra gallardía, holgaré de que me veais. (224)

["Don't be importunate; I have a house; tell a page to follow me, because despite the fact that I am more modest than what this answer promises, nevertheless, to see if your discretion matches your insistence, you will be able to see me."]

Ensign Campuzano's narration is more revealing of his motives than doña Estefanía's is of hers. Her first utterance, above, is flanked at its beginning by his admission of passion and at its end by his remark, "Beséle las manos por la grande merced que me hacía, en pago de la cual le prometí montes de oro" (224) [I kissed her hands for the great mercy which she did me, in payment for which I promised her mountains of gold]. She has already said to him, "I am more modest than what this answer promises," and she will not unveil herself unless, upon his visit to her house, he shows his discretion to be equal to his gallantry. His answer to this, although figuratively inoffensive (promising her "mountains of gold," equivalent to promising someone the world), blatantly offers money in return for sexual favors. The mentality in place in the text is clearly one of prostitution, but from the consumer's, rather than the seller's, perspective. This is because doña Estefanía is objectified in the text; her veil, which alludes to her untold story, functions not according to her own desires but only as a screen upon which Campuzano's, and the reader's, desires are projected.

What matters to Campuzano is the removal of the veil. His obsession with it completely objectifies doña Estefanía, an idea which is perhaps best supported by the fact that she is only thrice (and each time briefly) quoted in the text. This is not her story—she is useful to it only as a space behind a veil, as personified desire, a gap to be filled at any price, thus to aid in the production of narrative.

[62]

Marriage, Motherhood, and Deviance

In *Dissemination* and in *Spurs,* Derrida initiates discussions of meaning and truth in the metaphorical context of hymen and veil in the first work and veil in the second.[10] As in *Casamiento,* the veil and hymen appear in a context of seduction (in *Dissemination,* in relation to the scene from *Pierrot;* in *Spurs,* in relation to Nietzsche's conception of truth as woman). In both texts the veil and hymen are images of the undecidability of meaning and truth. In *Casamiento,* they are images of the undecidability of one woman's place in society. From the first, Campuzano construes of doña Estefanía as an object to be purchased; he offers her "montes de oro" in exchange for the opportunity to get past her veil. It is not enough to accept doña Estefanía as is, as a subject partly veiled and unveiled, that is, partly beyond definition and naming. Instead, there is an insistence on labeling her a prostitute, on fixing the constellation of meaning about her, so that a judgment can be made as to her complicity in the deception that is the story's informing attribute.

Readers search for someone on whom to blame the *engaño* that undermines marriage in the text, and their condemnation falls, implicitly and sometimes explicitly, on Estefanía's head—or, rather, on her veil. Perhaps Campuzano is spared because he is, in the act of telling his own story, able to redeem himself—if not by making excuses, then by making autobiography.[11] But Estefanía has no opportunity to tell her story, and the empty space where her narrative might have been becomes an irresistable repository for blame:

> She has used hypocrisy to deceive him; a frank and disarming admission of past hypocritical behavior: "pecadora he sido y aun ahora lo soy; pero no de manera que los vecinos me murmuren ni los apartados me noten" [I have been a sinner and I still am one; but not in any way that the neighbors talk about me or anybody else notice me] [—] is followed by the promise of "la enmienda de mi vida" and of the ideal marriage with all the domestic virtues of the *perfecta casada* [perfect wife].[12]

[63]

This promise comes after four days of flattery in which Campuzano tries, to no avail, to convince the woman to give him "el fruto que deseaba" (the fruit that he desired). In it, doña Estefanía explicitly states her requirements for, and desire for, marriage. She begins:

"Señor Alférez Campuzano, simplicidad sería si yo quisiera venderme a vuesa merced por santa." (225)

["Sir Ensign Campuzano, it would be ridiculous if I tried to sell myself to you as if I were some kind of a saint."]

Her marriage proposal is founded upon the necessity of selling herself. This is what makes the marriage "engañoso" (deceitful, artful, deceptive, misleading): doña Estefanía construes it, from the beginning, not hypocritically, but rather pragmatically, in terms of selling herself. She thus conflates the terms *wife* and *prostitute,* frustrating the opposition between the two that societal structures need to keep in place in order to find a woman to blame. She is selling herself, but only as a wife. Contemporary feminist arguments equating the economic ramifications of marriage with those of prostitution and the currency of arranged marriages for mutual benefit in the seventeenth century notwithstanding, doña Estefanía's offer falls within neither bawdy nor wifely contexts. What she proposes is neither here nor there, indefinable in terms of marriage or prostitution.

This refusal to identify as either wife or prostitute is, in the end, what makes the marriage deceitful. Estefanía's being between definitions of her body makes *engaño,* the deceit that is fiction, possible. The only way that she can have any presence in the narrative is by stitching up a fictive marriage-hymen, and that fiction is the one upon which Campuzano's ability to tell stories depends.

When Campuzano and doña Estefanía are discovered in bed one morning by doña Clementa, the bed's rightful owner, Campuzano asks his wife why they are being thrown out of the house. Estefanía replies:

—Y vos, señor, por mi amor que no os alboroteis ni respondais por mí a ninguna cosa que contra mí oyeredes. (228)

["And you, sir, *for love of me* don't make a fuss or respond for me to anything you might hear against me."]

And when he insists:

—No tengo lugar de responderos—dijo doña Estefanía—; sólo sabed que todo lo que aquí pasare es fingido y que tira a cierto designio y efecto que después sabreis. (228)

[—*I don't have space to answer you*—said doña Estefanía—; only know that everything that may occur here is made up, and that it's part of a certain plan and effect that you'll understand later.] (Emphasis is mine in both citations.)

Her last utterance in the story is in answer to doña Clementa's imprecations:

—No reciba vuesa merced pesadumbre, mi señora doña Clementa Bueso, y entienda que no sin misterio ve lo que ve en esta su casa; que cuando lo sepa, y sé que quedaré disculpada y vuesa merced sin ninguna queja. (229)

["Don't be upset, my lady doña Clementa Bueso, and understand that there is a mystery in what you see in this your house and when you understand it, I know that I will be cleared and you will have no complaints.".]

The second and third quotations promise an explanation—and that the explanation will be based on fiction. *Misterio* is the rationale given in the third; in the second it is that everything that is happening "es fingido y que tira a cierto designio y efecto"— is made up with an eye to a certain design and effect, that is, a fiction. Estefanía's artful marriage is a fictional hymen—a narrative woven between oppositions that construct meaning through woman,[13] which is untold in the telling of the dominant narrative.

After all, *Casamiento engañoso* is an exemplary novel. The exemplarity of *Novelas ejemplares* has been construed not in the sense

[65]

of the moralizing medieval *exemplum,* but rather as a proposition of models of human behavior, always imbued with the ambivalence that attends Cervantes's perspective.[14] But they are exemplary, too, of the processes involved in making and reading narrative. This is particularly true in *Casamiento/Coloquio,* in which the bodies of women characters who refuse convention are intimately related to the production of fiction. Doña Estefanía's activity in the text is an example of the way that fiction-making is related to the presence of deviant characters. Her nonexplanations give her room to function in the narrative: her status as woman in society cannot be established as long as she can maintain its definition in suspense. As long as she is able to deceive, *fingir* and make *misterios,* she is able to function in fiction.

But the time comes in *Casamiento* when the state of Estefanía's hymen is decided. One day when she is out attending to her business at doña Clementa's, Campuzano begins an informative conversation with the owner of the house in which they are temporarily seeking abode. This unnamed character inquires as to why Campuzano and Estefanía have been fighting so incessantly. The ensign tells her

"todo el cuento, y cuando llegué a decir que me había casado con doña Estefanía, y la dote que trajo, y la simplicidad que había hecho en dejar su casa y hacienda a doña Clementa aunque fuese con tan sana intención como era alcanzar tan principal marido como don Lope, se comenzó a santiguar y hacerse cruces con tanta prisa y con tanto 'Jesús, Jesús, de la mala hembra!' que me puso en gran turbación. . . ." (230–31)

["the whole story, and when I told her that I had married doña Estefanía, and about the dowry she brought, and the silliness she had done in leaving her house and estate with doña Clementa even though it were to such a wise intent as to get a husband like don Lope, she began to cross herself so rapidly and with so much "Jesus, Jesus, what a sleaze!" that I became very disturbed. . . ."]

He says that he tells this hostess "the whole story." But what he tells her is a story in which Estefanía represents an unknown,

untold element. As soon as the friend begins to exclaim "Jesus, what a sleaze!" and starts crossing herself as if she has seen a witch, the gap of doubt around Estefanía's blame or innocence begins to be filled. Her calling doña Estefanía a "mala hembra" gives us a clue as to what is to follow: the friend is the agent of the economy of honor, which at this point begins to attempt to take over the narrative. In order to preserve his honor, Campuzano must now control the woman whose slipperiness has stained it. The friend says:

"Señor Alférez, no sé si voy contra mi consciencia en descubriros lo que me parece que también la cargaría si lo callase; pero, a Dios y a ventura sea lo que fuere, viva la verdad y muera la mentira! La verdad es que doña Clementa Bueso es la verdadera señora de la casa y de la hacienda de que os hicieron la dote; la mentira es todo cuanto os ha dicho doña Estefanía. . . ." (231)

["Sir Ensign, I don't know if I'm going against my conscience in telling you something that I think would burden it even if I kept it quiet; but, no matter what, long live the truth, and death to lies! The truth is that doña Clementa Bueso is the true lady of the house and estate that they gave to you as dowry; the lie is everything that doña Estefanía has told you. . . ."]

Descubriros and *cargaría* are crucial words here. *Descubrir* is what Campuzano has been trying to do all along; when he first met doña Estefanía, his goal was to get her to dispense with her veil: "le rogué que se descubriese" (224) ["I begged her to discover herself"]. When he hears this story told over Estefanía's untold one, the undecidable is finally *descubierto*. Interestingly, it is discovered so that the friend, the author of this narrative, may avoid being the object of the verb *cargar*, to burden or to load. Intimate association with the untold story results in narrative contagion—Campuzano, we remember, was at the hospital sweating out the "cargas de bubas" (222) that he had got from Estefanía. The goal of the friend's narrative is to separate *verdad* from *mentira;* that is,

[67]

to decide the turn of the story in terms of clearly defined oppositions, to fill in the gaps rather than to promote further narrative. Thus, *cargas* must be avoided—both in the sense of the activity *cargar* (with the vulgar meaning "to have sexual intercourse") and its result, infection with syphilis—or the itch to tell a story.

But the conversion of the narrative into a case of honor is not yet complete. Even Estefanía's friend admits that ". . . bien mirado, no hay que culpar a la pobre señora, pues ha sabido granjear a una tal persona como la del señor Alférez por marido" (231) [". . . looked at the right way, there's no reason to blame the poor lady, since she has known how to earn such a personage as Sir Ensign for a husband"]. She can see excusing Estefanía on the grounds that she knew how to earn (*granjear*) such a husband—the conflation of wife and prostitute still leaves a hole in the text.

Because his honor is now at stake, Campuzano finds uncertainty intolerable. He decides to take up his

capa y espada y salir a buscar a doña Estefanía, con prosupuesto de hacer de ella un ejemplar castigo. (231)

[cloak and sword and go out to find doña Estefanía, with the purpose of making of her an exemplary punishment.]

He seeks Estefanía, but he cannot find her. She does not fit into the scheme of the dominant narrative; she does not become part of a patriarchal code of honor. Instead, when Campuzano returns to the friend's house, the friend tells him that doña Estefanía had come home in his absence, that she told Estefanía how upset and angry Campuzano had been, how he had gone out in a fury to find Estefanía—and that, as a result, Estefanía had fled from his supposed wrath, taking with her all of his belongings.

He forgot that "por mi amor" (for her love's sake) she had asked him not to respond to any talk he heard about her. When Campuzano entered, irrevocably, the narrative economy of honor, with its dependence upon rigid definitions, he did so already hav-

ing decided Estefanía's status. He tells himself an acceptable story to fill the gap in what Estefanía does not have time or space to tell him—"No tengo lugar de responderos" (228) ["I don't have time or place to respond to you"]. She has no narrative space in which to tell her side because her very narrative existence depends on untelling the conventions of matrimony and the definitions of classes of women. Campuzano must decide her place in the dominant categories of woman in order to preserve his idea of himself—he did not like what he discovered behind the veil. As a figure of undecidability, Estefanía could exist in narrative only beyond the strictures conventionally defining the veils/hymens of prostitution and matrimony. Thus, her response to Campuzano's anger is flight from his decisive sword. Unlike Celestina, she is not murdered for her deviance. But she does, in a sense common to bearers of the untold story, become "un castigo ejemplar;" because of Campuzano's insistence on fixing meaning, she disappears from the narrative, and the *historia* that she catalyzed comes to an end without her.

Yet, as Campuzano reminds us, he does not look for her: "No quise buscarla, por no hallar el mal que me faltaba" (234) ["I didn't look for her, because I didn't want to find the evil I was missing"]. Bataillon says that this is because death is the only way out of Campuzano's dishonored position, and so he must wait for it in penitence.[15] But on a narratological level, Campuzano does not need to find Estefanía because she left a trace of herself, and her untelling activity, with him in the form of syphilis.

As has been noted above, if Campuzano had not slept with Estefanía, he would not have contracted the disease that led him to the hospital and the feverish night of intermittent sleep in which he claims to have overheard *Coloquio de los perros*. Her illicit traces make it possible for him to claim authorship of that narrative.

I have noted that González-Echevarría proposes a reproductive metaphor for the genesis of *Coloquio*—that Campuzano's marriage results in his "fathering" a novel. Fathering is impossible without the indispensable, if disposable, woman. With Estefanía out of the story, who is the mother?

The Mother

There is a witch named Cañizares at the center of *Colloquy of the Dogs*.[16] Her function in the narrative has been described as follows:

> We have reached the monster at the *center* of the *labyrinth,* and, as we move through the *aborted* anagnoresis and witness the two dogs *groping* futilely for a correct exegesis of the prophecy that holds the promise of *release,* the narrative *grinds* toward a halt, leaving us with the impression of a dreamer mesmerized by a *relentlessly oppressive* nightmare. The briskly paced *flow* of episodes . . . [is] suddenly suspended, and the analytical texture of the work *thickens* toward the *density* of a metaphysical treatise. The *tightening involutions* of the tale, its continuing *thrusts inward* . . . appear to be approaching a *climactic dead center* of *convergence,* and the narrative itself seems to exert that *menacing, constrictive force* that we observe everywhere in the imaginary space of the novella and that becomes *stifling* in the *tiny cell* and in the spiritual *abysses* . . . from which the hag vainly attempts to extricate herself. (59–60; emphasis is mine)

In this fragment the witch is seen as the center of evil in the text, as the opposition to Christian redemption. But the language that is associated with evil reveals the degree to which heterodox femininity is often identified with evil. Because of the episode of Cañizares, "we plunge into the most profound strata of meaning infolded in the tale" (60). The vocabulary chosen here to illustrate evil is precisely that associated with paranoid descriptions of female sexuality. Cañizares appears here as an all-devouring womb. The only way to escape the "tightening involutions" of this "climactic dead center" is to "plunge into the infoldings" (60) in order to get at meaning. In other words, the only way to cope with the menace and horror stimulated by the unfathomable uncertainty that is the untold is to penetrate and name it, to fill in its gap with meaning. In the case of Cañizares, this name will be *witch.*

As it is necessary to the economy of the dominant narrative in *Casamiento* that the state of Estefanía's hymen be decided—that

Marriage, Motherhood, and Deviance

is, so that her indefinable action in the narrative can be controlled, she is fixed in the meaning, prostitute—so can the female body that produces and undermines discourse in *Coloquio* be controlled if Cañizares is named a witch. The epithet *witch* has a strong taboo value; it also contains an unerring value judgment that keeps its bearer within manageable semantic confines. Once a woman is defined as a witch, society knows what to do with her: she can be imprisoned or extinguished once she is identified.

At this point it may prove useful to review the plot of *Coloquio* in order to see what frightening feminine mayhem is at the origin of this desire to categorize and to name. *Coloquio*, it may be remembered, is framed by the tale of *Casamiento engañoso*. It is, according to Campuzano, a transcription from memory of a nocturnal conversation between two watchdogs at the Hospital de la Resurreción. Campuzano overheard it, he says, while recovering from his cure for the syphilis he contracted from doña Estefanía:

"a la mitad de aquella noche, estando a oscuras y desvelado, pensando en mis pasados sucesos y presentes desgracias, oí hablar junto, y estuve con atento oído escuchando, por ver si podía venir en conocimiento de los que hablaban y de lo que hablaban, y a poco rato vine a conocer, por lo que hablaban, los que hablaban, y eran los dos perros Cipión y Berganza." (236)

["in the middle of that night, being awake in the dark, thinking of my past deeds and present misfortunes, I heard conversation, and I listened with an alert ear, to see if I could figure out who was talking and what they were talking about, and pretty soon I came to know, from what they were saying, who was talking, and it was the two dogs Cipión and Berganza."]

As one might expect, he was impressed with this circumstance, so he listened, memorized, and then wrote it all down (237).

The licentiate Peralta thinks Campuzano is lying; but as the ensign points out, whether it is true or not, doesn't it sound interesting? "¿No se holgará vuesa merced, señor Peralta, de ver escritas en un coloquio las cosas que estos perros, o sean quien

fueren, hablaron?" (237) ["Wouldn't you like, señor Peralta, to see written in a colloquy the things that those dogs, or whatever they were, said?"] Peralta is won over—what matters is not the truth, but the virtuosity of the "engaño."

In terms of literary history, *Coloquio de los perros* is seen as Cervantes's answer to, and development of, the tradition of the picaresque in Spanish literature. Since the publication of *La vida de Lazarillo de Tormes* in 1554, the picaresque had been a burgeoning genre. Mateo Alemán's *Guzmán de Alfarache*, in particular, has echoes in Cervantes's story.[17] Like the hero of Alemán's picaresque, Berganza's first recollections are of life in Sevilla. Also, Berganza narrates episodically, in the first person, his servitude under various low-life masters; how he, from association, falls into a life of crime and then is finally led to a life of penitence— in this case, as a watchdog and alms-collector for the Hospital de la Resurreción.

Also like a conventional pícaro, Berganza had what critics of the picaresque uniformly call a doubtful birth. The doubt is not whether or not he was born but rather who the pícaro's father is. The doubtful paternity of the pícaro, which is the direct result of his mother's unbridled sexuality, is a standard trait of the picaresque novel. In *Lazarillo, Guzmán,* in Quevedo's *Buscón,* a pattern is established for the picaresque: true to its rhetorical parallels with the legal *relación,* or official account of one's life, the picaresque must begin with a statement establishing who the protagonist's parents were or might have been.

Invited by Cipión to go first, Berganza begins to tell his story in the orthodox way:

"Paréceme que la primera vez que vi el sol fue en Sevilla, y en su Matadero, que está fuera de la Puerta de la Carne; por donde imaginara (si no fuera por lo que después diré) que mis padres debieron de ser alanos. . . ." (245)

["It seems to me that the first time I saw the sun was in Seville, in the slaughterhouse district, which is outside the Gate of Flesh; from that

Marriage, Motherhood, and Deviance

I would imagine (were it not for what I'll tell later) that my parents must have been mastiffs."]

The form of providing a genealogy for himself is present, but Berganza shows that his birth is doubtful in two ways—first, that like many a pícaro, he is not sure who his parents are; second, that he is not sure where he was born. Every verb relating to his birth is in the subjunctive mood, and everything he says is undermined by the contrary-to-fact "si no fuera por lo que después diré": were it not for what I'll tell later. The act of narrating is linked somehow to his problematic birth and is undermined by it. This association of narration and birth is reinforced by the beginning of *Coloquio*. In its first sentences, the dogs problematize, in the space reserved in the picaresque for elaboration of paternity, their entry into language.

They construe their ability to talk as something that "pasa de los términos de la naturaleza" (241) [goes beyond the bounds of nature]. They find even stranger the fact that they are capable of reasoning, that they are self-conscious (242). And yet both dogs admit that this opportunity is something that they have wanted for a long time (Cipión says, "de mí por largos tiempos deseado" ["desired by me for a long time"]). Berganza adds,

"Y aún de mí, que desde que tuve fuerzas para roer un hueso tuve deseo de hablar, para decir cosas que depositaba en la memoria." (244)

["And even by me, because since I was strong enough to gnaw a bone I had the desire to talk, to say things that I had stored up in my mind."]

So it appears that the dogs were only mute before this miracle; that they had previously acceded to consciousness but could not articulate sounds into language. Desire and language are commingled in their commentary; when they speak, they become aware of the lack of speech they suffered and of its possible loss again. It appears that at some point they have moved into the Symbolic,[18] and become split subjects capable of language and of desire.

Their first utterances are dominated by an awareness of lack. That this sensation should accompany the accession to language is not surprising since, according to Lacanian theory,

> Symbolization starts, therefore, when the child gets its first sense that something could be missing; words stand for objects, because they only have to be spoken at the moment when the first object is lost.[19]

That lost first object is what Berganza will tell later, "lo que después diré."

After these mysterious asides about his problematic beginning, the form of Berganza's story becomes more traditionally picaresque. He tells about all the masters he has served to date. There are ten of these episodes; but in the midst of them, after the fifth and before the sixth, there is a story between; it is the account of Cañizares.

Berganza has been working as a dancing dog for a street performer. One day they arrive in Montilla and begin to put on a show in front of a hospital. His master exhorts him to ever higher leaps in honor of various scabrous local personages, finally commanding him to do some more "a devoción de la famosa hechicera que dicen que hubo en este lugar" (290) ["in devotion to the famous sorceress who they say used to be in this place"]. As soon as these words leave his lips, the hospitaler, an old woman, yells:

> "¡Bellaco, charlatán, embaidor e hijo de puta, aquí no hay hechicera alguna! Si lo decís por la Camacha, ya ella pagó su pecado, y está donde Dios se sabe; si lo decís por mí, chocarrero, ni yo soy ni he sido hechicera en mí vida; y si he tenido fama de haberlo sido, merced a los testigos falsos, y a la ley del encaje, y al juez arrojadizo y mal informado; ya sabe todo el mundo la vida que hago, en penitencia, no de los hechizos que no hice, sino de otros muchos pecados, otros que como pecadora he cometido." (290)

["Liar, cheat, charlatan, son of a whore, there's no sorceress here! If you say it about Camacha, she's already paid for her sins, and is God

knows where; if you say it for me, liar, I am not, nor ever have been a sorceress in my life; and if I have the reputation of having been one, thanks to false witnesses, unfounded judgments, and a misinformed judge; now everyone knows what kind of life I lead, in penance, not for the spells I did not cast, but for many other sins, which I as a sinner have committed."]

After this outburst, the performer shuts down the act, and his frustrated customers leave, doing exactly what the woman wanted to avoid: "Fuese la gente maldiciendo a la vieja, añadiendo al nombre de hechicera el de bruja, y el de barbuda sobre vieja" (291) ["The people left cursing the old woman, adding the name witch to that of sorceress, and that of bearded to crone"].

Thus, the introduction of Cañizares is in the context of naming and fixing meaning, despite the attempt to avoid imposed names and meanings. (If she is pinned down as a witch too early, she will be unable to tell her story.) In her turn, Cañizares names the dog; she calls him, "Hijo, Montiel" (291) and tells him to come to her room that night, so that she can tell him about his life. He is terrified and confused, but curious, so he goes that evening to meet her. She greets him like a long-lost friend and immediately launches into a biography of Camacha of Montilla, the famous witch to whom his master alluded earlier with such disastrous results. One of her great skills (among hymen mending and changing the weather) was that of turning human beings into animals.[20] Cañizares is jealous of this skill, and says:

"lo que me pesa es que yo ni tu madre, que fuimos dicípulas de la buena Camacha, nunca llegamos a saber tanto como ella; . . . Tu madre, hijo, se llamó la Montiela, que después de la Camacha fue famosa." (293)

["what bothers me is that neither I nor your mother, who were disciples of the good Camacha, ever came to know as much as she did; . . . Your mother, son, was called la Montiela, who was almost as famous as Camacha."]

So, Berganza's mother was a human being, one of a trio of famous witches.[21] Camacha even assisted as midwife at his birth; and when she discovered that his mother had delivered dogs instead of babies said that she would cover it up if their mother would keep it quiet, because

"este perruno parto de otra parte viene y algún misterio contiene." (294)

["this canine birth comes from somewhere else and has some mystery in it."]

Years later, on her deathbed, Camacha confessed that it was she herself who had turned the babies into dogs, out of jealousy and fear that their mother would surpass her own magical skills.

After revealing the source of the dogs' ability to speak, Cañizares begins a long disquisition on her past as a witch, full of details of sorcery and spells, with elaborate commentary on the Sabbat and the unguent witches use to get there (295–301). This conjunction of explanations of the origin of speech and of witchcraft is highlighted by the fact that Cañizares proceeds to tell a story immediately after the revelation. She, like the dogs, finds the power to speak through some kind of sorcery. Thus, unlike any other woman in *Coloquio*, she narrates her own story.

The distinction between Cañizares, who contructs her own heretical narrative economy, and the women characters in the text who remain within the structures of the dominant narrative is striking. In the first episode of *Coloquio*,[22] there is the *amiga*, or girlfriend, of the butcher Nicolás el Romo (248). In the second, there is a flashback reference to the same woman as the person who introduced Berganza to the pastoral novel. As such, she is the bearer of conventional narrative (251). The third episode, that of the rich Sevillian merchant, presents a black woman who is a slave. She bribes Berganza with treats so that he will not bark at her lover (269–73). When she forgets to give them to him, Berganza scratches her and flees her wrath. Next, he goes to work for a police officer, and two more women appear: the prostitute

Colindres, who is an accomplice to their scams, and a landlady who gets caught in one of their operations. Interestingly, the presence of Colindres in her house, provoking a disturbance, makes it possible for the landlady to speak, briefly, in her own defense (276–77; 279).[23] Her discourse has limits, however, because of her subservience to the law of the dominant narrative, as personified in the policeman.

After the officer betrays him, Berganza finds a job with the drummer who brings him to Montilla. There may be women in the drummer's life among the "seis camaradas [que] sustentaba como unos reyes" (287) [six friends whom he supported like royalty]. These are mentioned in passing as evidence that Berganza was helping his master earn a good living.

The next episode is that of Cañizares, and it marks a change in the relation of women characters to the production of narrative. With the exception of the landlady, all of the women before Cañizares are intimately and explicitly attached to men and controlled by them either sexually or financially (or both). The landlady is censored because she tries to expose the behavior of the officer and his cronies for the cheating fiction that it is; her too direct confrontation with the dominant narrative lands her in jail.

After Cañizares, there are only a few more mentions of women. The first is in the episode of the gypsies; of gypsy women, Berganza says, "Todas ellas son parteras" (307) ["all of them are midwives"]. Midwifery defines these women, a fact that establishes a relationship between them and another tricky midwife descended from Claudina and Celestina: Camacha. The gypsies are like these deviant women in that they practice necessary, but heretical, arts. The difference between the gypsies and Cañizares, though, is that (as the text says immediately after it explains their midwifery):

Cásanse siempre entre ellos, porque no salgan sus malas costumbres a ser conocidas de otros. (307)

[They always marry among themselves, so that their evil ways do not become known to anyone else.]

[77]

The gypsies are outside the constructs of the dominant culture; they do not participate in its narratives, and they do not tell it their stories. Unlike Celestina and Cañizares, they have no intercourse with that society. Similarly, their sexuality is restricted:

ellas guardan el decoro a sus maridos, y pocas hay que les ofendan con otros que no sean de su generación. (307)

[they protect their husbands' honor, and there are few who offend their husbands with other men not of their race].

The next mention is of the "mozas vagamundas" (vagabond girls), whose plight prompts Berganza to try to speak to the powerful Corregidor of Valladolid. Instead of speech, cacophonous barking emerges from his mouth, and the Corregidor has him brutally ejected into the street.[24]

Coloquio's last allusion to a woman is to "una señora principal" (320–21) (an important lady), whose tiny lapdog is rude to Berganza. The women in both episodes catalyze philosophical responses from the dogs, but they have no narrative existence of their own. Like the gypsy women, they describe the extreme possibilities of conventional femininity in *Coloquio's* world: homelessness, absurd privilege, or exclusion from the dominant culture's benefits and perils.

Unlike the other women in *Coloquio*, Cañizares is both inside and outside the dominant society. She works in the beneficent and Christian profession of hospitaler, but in the evening, fully conscious of her contradictions, she anoints herself with witch's unguents. Her sorcery effects a change that is, at least, efficacious for herself—her spells bring her the power to create a subversive narrative within the main story.

The specific name she gives to this discourse-producing magic is *tropelía*:

sé que eres persona racional y te veo en semejanza de perro, si ya no es que esto se hace con aquella ciencia que llaman *tropelía*, que hace parecer una cosa por otra. (292)

[I know that you are a rational person and I see you in the form of a dog, but that this is done with that science that they call *tropelía,* which makes one thing appear for another.]

According to L. J. Woodward, *tropelía* is not a substantial change but rather "an apparent change brought about by trickery."[25] The witch knows how to make one thing appear as another; in other words, *tropelía* gives control over the processes of signification and sidesteps binary opposition in order to produce multiple and simultaneous differing meanings (talking dogs), identities that are never certain (are the dogs enchanted babies?), and endlessly deferred definitions of these ecstatic signifiers, as posited in Camacha's prophecy:

Volverán en su forma verdadera
cuando vieren con presta diligencia
derribar los soberbios levantados
y alzar a los humildes abatidos
por poderosa mano para hacerlo. (294)

[They shall return to their true form/when they see with ready diligence/the throwing down of the elevated proud/and the lifting up of the downtrodden humble/by a hand powerful to do it.]

The prophecy indicates an inversion of hierarchies, but not a release from hierarchical structures. When the proud are cast down, they become "downtrodden"; when the humble are lifted, they become "elevated"—the cycle of dominance continues. The resonances of the passage with Virgil and the Magnificat[26] are ironic; Camacha's words promise not restoration but rather an endless repetition of oppressive structures, to those who would seek to end the effects of her *tropelía*. The end of illusion, of *engaño* and *tropelía*, would be the end of fiction.

That Cañizares is a witch is interesting on many levels. But the insistence on naming her a witch has a function specifically related to the untold story: it helps to divert attention from the central fact of production of narrative in the text, which is that

of motherhood. As I have tried to show in the case of *Celestina* and in *Casamiento,* deciding the identity of a multiple-meaning, elastic gap puts an end to narrative. One of Cañizares's functions in *Coloquio* is to protect the gap of its origin from being filled in with a meaning that would weld it immovably into the dominant narrative's framework. This gap is the story of the origin of mystery in discourse, the unknown, unreadable absence that invisibly affects and stimulates the making of text. It is that which, in the quotation that began the discussion of *Coloquio,* is metaphorized as an uncontrollable womb and is represented in the text as the untold story of Montiela's delivery. The witch is a powerful emblem of sexuality in the Western consciousness, but never one of reproduction. She is accused of making men impotent, of procuring abortions, and of killing infants. These fantasies are undermined in *Coloquio* by the fact that one witch, Camacha, (historically, like many women persecuted for witchcraft)[27] is a midwife, and the other, Montiela, is a mother who may not be married. Montiela is not permitted to tell any story; all she can do is narrate with her body, by giving birth. She is as deeply embedded in this narrative as Celestina's friend and mentor Claudina is in *Tragicomedia.* In both cases, these are women who are outside the control of patriarchal society. The texts seem automatically and unconsciously to censor the independent friendships of deviant women, upon whom, like it or not, they depend for their narrative energy; the actions of deviant women motivate the narrative. It is true, as Camacha says, that this canine birth comes from somewhere else and contains some mystery: but it is a birth nevertheless. These weird women bring life, not death, to the narrative. As Cipión says at the beginning of the story, the dogs' discourse and the gap it marks move beyond the bounds of nature—not because Campuzano fathers a narrative without a woman, but because two supernatural women give birth to dogs and to discourse.

The separation from the body of the mother that is necessary under the terms of the dominant narrative is what makes it possible for Cipión and Berganza to speak. This separation, en-

trenched in the ambiguity and stories within stories that form the narrative and enfranchised by the repression of the functions of nonpatriarchal midwife and mother, leaves the untold story of Montiela untold. The gap surrounding the birth of the babies and the speech of the dogs is protected by the confessions of Cañizares, who tells her own subversive witch story, one that can be tolerated because its definition can be controlled by the textual order in place in the dominant narrative.

CHAPTER 5

Voyeurism and Paternity: Reading *La tía fingida*

In *Casamiento engañoso* and *Coloquio de los perros*, the undecidable quality of a deviant woman's status in the dominant narrative's systems of definition is associated with both the subversion and the production of that narrative. In *Casamiento*, the untold story depends upon Estefanía's suspension between the definitions *wife* and *prostitute;* while in *Coloquio*, discourse comes into being as a result of a conflation of the mutually exclusive terms, *mother* and *witch*. Both texts, like *La Celestina*, attempt to define a woman in question in terms of the state of her body in relation to patriarchy; specifically, in terms of the condition of her hymen as it relates to virginity, marriage and motherhood. With each work, the suspension of decision regarding some crucial hymen constitutes a space for desire, a space that has the effect of a narrative catalyst—until its undecidability becomes intolerable to the structure of a dominant narrative. At this point its meaning is decided, its bearer eradicated from the story, desire extinguished, and fiction stopped.

One of the most interesting things about *La tía fingida [The Pretended Aunt]*[1] is that, after the first third of the story, the state of the hymen is already decided. Nevertheless, the story proceeds after the revelation of this matter, offering ever more detailed

[83]

information on the subject. Also, perhaps significantly, "for the past 300 years or so a number of literary critics have been agonizing in a most peculiar fashion about the authorship of these stories."[2] One of the reasons that the critics have been in agony is that the explicitness of *La tía fingida* is irritating in two ways: first, it fails to fill up the hole in the text; second, the story, despite the voyeuristic interest that its explicitness supplies, is offensive because of its association with two texts attributed to the arch-canonical author Miguel de Cervantes. The problem is one of attraction-repulsion: the explicitness of the text is voyeuristically fascinating, but the pleasure obtained from reading it is undermined (and perhaps intensified) by the fear that it may be the work of a great author, who should not stoop so low, or the fear that it is not written by a great author, in which case there is no excuse for reading it. These reactions stem from identification with the author as father and fear of offending him in the persons of his sons (the critic's colleagues) by either acknowledging or disputing his paternity of a problematic text. This chapter will try to show that the telling of the untold story in *La tía fingida* has the effect of exiling the text itself from literary legitimacy.

The story begins with two students from the university of Salamanca strolling through the streets looking for something to do. They become interested in the fact that a familiar storefront on their route is now covered up by blinds (a *celosía*). A neighbor tells them that an august old woman, her beautiful niece, two *dueñas* and a footman have been living there for eight days. Judging from their demeanor, their strict retirement and the fact that they have had no visitors, he assumes that they are "gente honrada" [honorable people] and of the upper class. But the students are suspicious and think that the aunt and niece, since they are in a university town but are not students, may be courtesans. So they loiter, waiting for their chance to get a look at the niece. Around midday, they do and are so taken with her that they decide to spend what little money they have to serenade her that evening.

Their efforts do not bring her to the window but rather bring

the police down the street, and the serenaders are disbanded. The students, as a last resort, go to the home of a rich playboy and try to enlist his services in conquering the damsel. He assents and the next day obtains an audience with one of the *dueñas,* Grijalba, who is the ambassador of Claudia, the aunt—but only after Claudia has had him investigated "como si le hubiera de tomar por verdadero yerno" (357) [as if she were going to take him for a real son-in-law]. But the playboy, Félix, wants to know the truth about the niece, too; so he plies Grijalba with wine. Initially, she replies to his questions with "una mui formada mentira" (357) [a well-fashioned lie], which is that the niece, Esperanza, is as much a virgin today as the day she was born. But after she is softened up with booze and a bribe, she tells the truth: that Esperanza thrice has been sold as a virgin and that Félix is supposed to be the next customer. Whether he finds this titillating or offensive is unclear, but he plots with her to gain admittance to the house so that he can converse with Esperanza without her aunt's knowledge. Grijalba easily agrees to this and that evening installs Félix in an alcove in Esperanza's room, behind the bed curtains. Esperanza knows that he is in the house but not where he is.

In the meantime, Aunt Claudia becomes garrulous; she and Esperanza start talking, within Félix's earshot. She begins a lecture on the amorous qualities of men from various regions of Spain, since her next client will be drawn from among the cosmopolitan population in Salamanca. But Esperanza gets tired of listening and finally says that she will not endure any longer, especially since the harangue is meant to exhort her to a new offering of her old virginity. Esperanza says that Claudia's methods of impersonating an intact hymen are too painful and that she will not submit to needle and thread again. Claudia is outraged, but Esperanza insists and says that she could make just as much money as a regular prostitute (not just as a "virgin") and that their reputation is not at risk since they will be leaving town soon anyway to be in Sevilla for the arrival of the fleet. At this point, her complaint is interrupted, suddenly, because Félix is taken with a fit of sneezing. He is discovered by an indignant Claudia, who

protests in defense of her honor. Félix insists that he is discreet and not out to ruin her reputation; the only reason he is there is to enjoy Esperanza.

But Claudia keeps yelling. In order to quiet her down, and as a token of his good faith, Félix offers her a heavy gold chain. Once Grijalba sees the loot, she tells her mistress to take it and shut up. But Claudia maintains her argument in favor of honor and Esperanza's virginity. This exasperates Grijalba, who puts Esperanza's hand in Félix's and gives them her blessing. Claudia, outraged at this insubordination, strikes Grijalba, who responds by pulling on Claudia's bonnet and revealing her mistress' bald pate. The infuriated Claudia calls for police, who are already in her house and who, along with some curiosity-seekers and the two students from the beginning of the story, have heard everything that has gone on in the bedroom.

From this point, the story moves quickly to its conclusion. Having caught the women confessing their crimes, the police take them off to jail. But the students, still not giving up, recruit some of their friends and steal Esperanza from the police escort. When they get her to their rooms, one student wants to rape her, but the other says he loves her and that evening takes her to his senile father's house and marries her, having easily convinced the old man that she is the daughter of a nobleman. Claudia, however, is given 400 lashes and is left exposed in a cage in the plaza, having been found guilty, in the course of the investigation of her pandering, of sorcery. The narrative ends with the wish that all women like Claudia would meet a similar end and the regret that so few women like Esperanza escape their miserable lives.

From this summary, it may be seen that some themes of the story are desire, deception, prostitution, eavesdropping, punishment, matrimony, and moralizing. These themes attend, in similar combinations, other works of the Spanish Golden Age, among them *Celestina*.[3]

R. Foulché-Delbosc has shown that there are many other references to hymen mending in Spanish literature and adds that, after all, the manuscript in which *La tía fingida* appears was ad-

dressed to an archbishop,[4] so that it is pointless to be too prudish about it. The story also has antecedents in Pietro Aretino's *Raggionamenti*,[5] which talk about prostitution and its attendant practices in great and spirited detail. The subject matter of *La tía fingida* is not without well-known precedents and could not have been surprisingly shocking to readers who were aware of those precedents. With this in mind, it is possible to think that the subject matter of the text is not what has stimulated so much controversy around it—something else is more important in the minds of the readers.

The critics who have written about *La tía fingida* have set aside the task of reading the text itself, as a whole, to see what it says and does not say. Instead, critical attention has been given to the question of the text's paternity (*paternity* is precisely the word that most critics use). The question posed is not, who is the father? but, rather, is or is not Cervantes the father? This apparently disturbing doubt is precipitated by the fact that *La tía fingida* appears in a manuscript with two stories that comprise part of the edition of Cervantes's *Novelas ejemplares* that he published in 1613. These two stories are *Rinconete y Cortadillo* and *El celoso extremeño [The Jealous Extremaduran]*. The difficulty is that the Porras Manuscript (ca. 1604)[6] in which the three stories appear has *La tía fingida* and *Rinconete y Cortadillo* written in one hand, and *El celoso extremeño* written in a different hand, but with emendations and notes in the hand of the first writer. Apparently, the fear at the base of the issue is that if Cervantes did not write *La tía fingida*, then he may not have written *Rinconete* or *El celoso extremeño* and is a plagiarist like the Avellaneda he despised (this is the opinion advanced by E. T. Aylward). On the other hand, if Cervantes's reputation as father of the two novellas is to be upheld, then *La tía fingida* must be admitted to the Cervantes canon as well. Bringing this dubious aunt into the family would render invalid some scholarship and disrupt the systems of relationship established between Cervantes's works and between the works, their readers, and criticism. Thus, it should come as no surprise that "critics have not known what to say about . . . [it],

and *La tía fingida* has been treated as one of the bastards of Spanish literature for centuries."[7]

In using the term *bastard,* Aylward connects his criticism with the thematic figure that has dominated scholarship on *La tía fingida*—that of dubious paternity. Without exception, critics have examined the work in the context of its possible attribution to Cervantes; perhaps they extrapolate upon the paternity figure that Cervantes uses in his prologue to *Novelas ejemplares:*

... yo soy el primero que he novelado en lengua castellana; que las muchas novelas que en ella anda impresas, todas son traducidas de lenguas extranjeras, y éstas son mías propias, no imitadas ni hurtadas. Mi ingenio las engendró y las parió mi pluma, y van creciendo en los brazos de la estampa.[8]

[... I am the first who has novelled in Castilian; the many novels in Spanish that are in print are all translated from foreign languages, but these are all my own, neither imitated nor stolen. My genius engendered them and my pen gave birth to them, and they continue growing in the arms of the printing press.]

Cervantes's approach in his prologue is to insist upon his originality and to buttress it with the metaphor of birth and paternity, as if the works were extensions of his body. Cervantes's construct excludes the body of a woman from this reproductive scenario, however. His pen becomes a phallic womb[9] that gives birth to the texts; a woman is only useful, later, as a wet nurse—that is the part played by "la estampa," the printing press.

But, in his prologue, Cervantes claims paternity of the twelve tales included in the original 1613 edition of *Novelas ejemplares.* This does not include *La tía fingida,* so Cervantes can hardly be blamed for inciting readers to continue his metaphor in regard to a text he does not claim. Nevertheless, having made the connection with Cervantes (because the manuscript that contains *La tía* contains two known exemplary novels), critics seize upon the irresistable and demanding paternity metaphor.

The first critic of the story, D. Isidro Bosarte, who discovered

the Porras manuscript in 1788,[10] cites Cervantes's paternity quotation in his second paragraph and insists, "Nadie, que sepamos, ha dudado que Cervantes es el autor, y padre legítimo de estas Novelas . . ."[11] [No one, that we know of, has doubted that Cervantes is the author and legitimate father of these Novels . . .]. But Bosarte refuses to comment on *La tía fingida* "porque ignoro si esta Novela se ha impreso alguna vez"[12] [because I do not know if this novel has been printed at any time]. He concentrates instead on the troublesome question of Cervantes's relationship to the two novels that have already been attributed to him. Thus, in this first instance, *La tía* is seen as irrelevant because it does not already bear Cervantes's name. The same thing occurs with the next (1797) critic of the Porras manuscript, D. Juan Antonio Pellicer—he does not even mention the text.[13]

This is not the case with D. Agustín García Arrieta, who, according to Aylward:

cast himself in the role of Bosarte's collaborator and literary executor by completing, after Bosarte's death, the latter's project of publishing the Porras text of *TF*. Arrieta's 1814 edition of this story is, however, nothing more than a butchered and bowdlerized version of the original.[14]

Perhaps Arrieta could conceive of admitting the text into the Cervantes canon only in a mutilated state; what is certain, though, is that, with strong phrases, he insists (although without evidence) on the work's attribution to Cervantes and that he does so in terms of paternity. He says that the novels of the Porras manuscript are "hermanas carnales" (blood sisters) of the novels in *Novelas ejemplares,* that *La tía* "es hija legítima" (is a legitimate daughter) of Cervantes, that it is the best of his works, and, finally, that Cervantes "es su legítimo autor" (is its legitimate author).[15] Arrieta supposes that the reason that this signal example of Cervantes's literary art is absent from his edition of *Novelas ejemplares* is that the great author misplaced it during his many travels.[16] There is no factual evidence to support Arrieta's conclusion.

That something is awry in the otherwise straight-forward, positivistic philological scholarship on texts of this vintage is evidenced by Aylward's comment that

> Arrieta's imaginative kind of scholarship becomes even more disturbing because it is complemented by an almost total lack of integrity and respect for factual information. And yet so many of the fantastic theories that Arrieta conjured up to support the case of Cervantes' authorship of the three texts found in Porras were unquestionably accepted by many critics who followed him.[17]

Even when their responses are calmer, critics tend to maintain the paternity metaphor. After Arrieta, the next critic in chronological order is D. Martín Fernández de Navarrete. He is measured and careful, as he was when he edited "the first edition of the *Tía* that is faithful to the Porras text"[18] in 1810. Still, in reference to the story, Navarrete uses the expression "dar a luz."[19] The first meaning of this phrase is "to give birth to"; but a second and oft-used meaning is, "to publish." At least in Spanish, this conflation of meaning points to the perception of the text as body.

D. Bartolomé José Gallardo, in 1835, responds to an anonymous letter suggesting that *La tía* was not written by Cervantes with vehement protestations in defense of the author's honor:

> Cuando se atraviesa el honor de un Ingenio Español tan privilegiado como el de Cervantes, hasta las piedras hablan; . . .[20]
>
> [When the honor of a Spanish Genius as privileged as Cervantes is impugned, even the stones speak; . . .]

The attribution of the story, one way or another, has become a matter of honor; in other words, a problem of social relations and prestige attached to a man's name.

Three book-length studies, with editions of the novel, appeared in the first years of the twentieth century: P. Julián Apráiz's in 1906, Adolfo Bonilla y San Martín's in 1911, and J. T. Medina's in 1919. Apráiz affirms that *La tía* "es, efectivamente una

obra descarriada de Cervantes"[21] [it is, evidently, a stray work by Cervantes] and refers to the text as an *hija* [daughter]. Medina comes to the same conclusion, albeit in a more roundabout way, as he details his sinuous approach to his conviction: after his own first reading, he thought only Cervantes could have written the story; then, he believed the hypothesis of Andrés Bello, that the text was written by Avellaneda; next, he found Icaza, whose book's title, *De cómo y por qué La tía fingida no es de Cervantes* [*How and Why The Pretended Aunt Is Not by Cervantes*], is self-explanatory, convincing. But finally, trusting his own instincts and stylistic comparisons, Medina came to the conclusion that Cervantes wrote the text. His vacillations about "la paternidad de la obra" [the paternity of the work][22] are emblematic of the need to assign paternity to the text and its inevitable frustration.

Bonilla y San Martín is more moderate, but after admitting that "la cuestión permanecerá indecisa" [the question will remain undecided], he says that if he were forced to choose, he would say that the text is by Cervantes:

Puesto, sin embargo, entre la espada y la pared; es decir, habiendo de determinarme sin excusa entre afirmar que *La tía* es de Cervantes, o negarlo sin rodeos ni callejuelas, yo confieso que optaría por lo primero.[23]

[Placed, nevertheless, between the sword and the wall; that is to say, having to determine myself without exception between affirming that *The Aunt* is by Cervantes, or denying it without circumlocution, I confess that I would opt for the former possibility.]

This somewhat obsessive insistence on naming a work that is anonymous has continued into recent years. In 1953, Manuel Criado de Val, by a minute comparison of the uses of the verb *amar* [to love] in *La tía* and other works by and not by Cervantes, concludes that neither Cervantes nor Avellaneda wrote it. It is interesting that he chose the verb "to love" as his tool of comparison; love becomes an object of exchange between texts.

In 1980, in a circumspect final chapter to his work on *Novelas ejemplares,* Julio Rodríguez Luís provides a useful and up-to-date

survey of most features of the work and of its criticism. Rodríguez says that

> la atribución a Cervantes de *La tía fingida* entraña una suerte de sacrilegio, pues anda muy lejos la novelita, con sus torpezas estilísticas . . .[24]
>
> [Attributing *La tía fingida* to Cervantes contains a hint of sacrilege, since the little novel wanders very far, with its stylistic weaknesses . . .]

His use of the word *sacrilege* points towards the intensity of feeling surrounding the matter, due to its subversion of orthodox structures.

Finally, Aylward's conclusion in 1982 is that Cervantes wrote none of the novels in the Porras manuscript[25] but used two of them, *Rinconete* and *Celoso extremeño*, as source material. Despite Aylward's wary and heavily documented approach, though, his conclusion is only a suggestion, not a definition, in the face of a great gap in certainty. Additionally, aside from his very thorough review of the criticism, he avoids advancing his own ideas on *La tía*, preferring instead to concentrate on the other two already attributed novels. Nevertheless, his conclusion is another attempt at pinning the between that is *La tía* down on one side or another of a binary opposition.

Strong and emotional reactions, not to the salacious matter of the text but to the question of its attribution, which to this day is undecidable, characterize the scholarship on *La tía fingida*. Even Aylward, who makes an attempt to remain calm in the face of the controversy, appears to be appalled. Fantasizing and theorizing without factual basis characterize Arrieta's and other critics' approach to the text. Perhaps the problem is not that they doubt or cannot prove the Cervantine connection in *La tía* but rather that they are attempting to prove their own authenticity, to attribute themselves somehow to Cervantes. This sort of critical approach would tend to make of the text an object of exchange between critics. As may be seen from a survey of the criticism

Voyeurism and Paternity

on the text, very little attention has been paid to reading or interpreting the text itself as a whole, just to see what it is about—no one provides even a plot summary. There are studies that do exhaustive historical and linguistic work (Apráiz's, Bonilla y San Martín's, Medina's, Aylward's), but the labor is all with the intent of either attributing or dissociating the work from Cervantes's name. It has been interesting only in terms of its paternity, in terms of the name of its father, from which it derives its only value. In Irigaray's terms, it serves "to uphold the reign of masculine hom(m)osexuality" in that it marks "the possibility of, and potential benefit in, relations among men."[26] But this text, in particular, persistently shrugs off definition because no father's name can be made to stick to it. As such, it is a perennial problem and becomes marginalized.

Perhaps this can be attributed, in part, to its theme. *La tía fingida* is pornography in the strictest etymological sense of the word: *porne* (prostitute) *graphos* (writing). It is *prostitute writing* in two ways. Most obviously, on the level of plot, it is a story about prostitutes. But it is also prostitute writing in the sense that it is writing that, not fitting the name of the father, is made to serve as a use object between men, both inside and outside the system of relations, all despite the gnawing suspicion or admission that it is some man's "daughter." The desire to situate this daughter as one man or another's property is in line with the desire to inscribe, by means of some phallus, a name on the hymen-text.

It is, of course, a coincidence that *La tía fingida,* a story about prostitutes and hymen mending, should itself be treated as a prostitute and hymen in the system of exchange in place in literary criticism; but its situation in that system is illustrative of the degree to which a text may be objectified in the service of its readers' projections.

One way to deal with the problem would be to ignore the text altogether. But, because of the Cervantes connection, critics have been unable to do this. Leaving the *Aunt* out does not solve the problem either. The position of the story between boundaries

imposed by canonical categorization makes a gap of it, a deep hole that readers tend to abhor. Only Foulché-Delbosc refuses to state an opinion one way or another and advises:

> On ferait sagement, en Espagne, de se méfier de cette tendance au dogmatisme dont les manifestations sont par trop fréquentes, et de se rappeler qu'en matière de recherches littéraires comme en bien d'autres, il est sage de professer parfois un agnosticisme résigné. (289)

[One would be wise, in Spain, to mistrust this tendency towards dogmatism which manifests itself too frequently, and to remember that in the matter of literary research as in others, it is wise at times to profess a resigned agnosticism.]

As a result, despite the fact that its authorship is genuinely undecidable, the gap that it *is* provokes critical narrative and an urge to define. The story begins to function like a Rorschach blot or like tarot cards: it becomes a screen upon which the reader may direct his projections, but any meaning it may have beyond those projections is ignored. No amount of elaborate stylistic comparison, or of detailed linguistic analysis, can establish the paternity of the text. Nevertheless, the uncertainty as to whether the text is a bastard, another rival heir, or irrelevant to the family of Cervantes's works is endlessly disturbing because it upsets the kinship structures in place in literary criticism: it threatens legitimacy (attribution) as a structuring concept. As a result, the text persistently returns from repression. It is not discussed, even tangentially, in many studies on *Novelas ejemplares*,[27] yet it appears in a number of editions of *Novelas,* both contemporary and antique. But when it does appear, it is either set off from the rest of the text[28] or preceded by a disclaimer that annuls its legitimacy:

> De la misma manera considero yo totalmente ajena a mi labor editorial el meterme en lucubraciones más o menos doctas acerca de si Cervantes escribió o no *La tía fingida*. Es mi opinión, tan convencida como subjetiva, de que Cervantes no la escribió. Pero esto no debe afectar para nada la opinión del lector.[29]

Voyeurism and Paternity

[In the same way I consider that it is totally irrelevant to my editorial work to embroil myself in more or less scholarly questions as to whether or not Cervantes wrote *La tía fingida*. It is my opinion, as firm as it is subjective, that he did not. But this should not in any way affect the opinion of the reader.]

All of this attention to the name of the father brings to mind the question of who a mother might be, and what if anything her name might have to do with the text. In one respect, the situation of doubtful paternity emphasized by criticism reflects a situation in place in the text: Esperanza knows neither her mother nor her father. Claudia is not, according to European systems of kinship, her aunt: she is just someone who stole her, as an infant, from a basket at a church door (370) and then used her for her own purposes. Nevertheless, Esperanza says that she feels that she must obey Claudia because "la tengo por madre y más que madre" (363) ["I have her for a mother and more than a mother"]. On one level, this usage of the term *madre* and *tía* was already established in *Celestina*, in which the women who work for her refer to Celestina using those familial references.[30] The other references to a *madre* in the text tie in with *Celestina* as well. The mother of invention in *Celestina*, that is, the person who made it possible for Celestina to make and unmake hymens, is her dead friend and teacher Claudina, who for her explicitness was punished by the law (see chap. 3). *Claudina* is a diminutive form of the name *Claudia*; both may derive from the Latin *claudo, -ere,* to close; in this case, to close hymens. (The verb also had the literary usage, *numeris* or *pedibus claudere,* to put into verse.) The names of these women connote text-making, and both women are associated with maternity. Aside from Alisa, who is Melibea's mother, Claudina is the only other woman in *Celestina* who is identified as a mother; she gave birth to Pármeno, Sempronio's sidekick, who with him murders Celestina.

In Spanish, the idea of motherhood is linked with the idea of virginity in the common phrase *como su madre la parió* (as her mother bore her). This phrase occurs three times in *La tía fingida,* and Apráiz confirms that

[95]

El decir de una mujer que está *como su madre la parió*, en el sentido de hallarse virgen, es fórmula muy corriente en nuestros días, como lo fué en los de Cervantes. . . .[31]

[Saying of a woman that she is *as her mother bore her*, in the sense of finding herself a virgin, is a very current formula in our day, as it was in that of Cervantes.]

This commonplace, which makes the birth mother the origin of her daughter's virginity, is inverted to make the hymen mender, that is, a maker of virginities, a young girl's mother. Because she controls the sign of Esperanza's virginity, Claudia is her mother. Thus, a form of kinship is established in which the process of signification and discourse becomes the most important determinant of relatedness:

Tiene consigo una doncella de estremado parecer y brío, que dicen ser su sobrina. . . . (349)

[She has with her a young woman of extraordinary *appearance* and spirit, whom they *say* is her niece. . . .] (Emphasis is mine.)

The signs of *honra* and virginity are authenticated by language. As long as discourse upholds those signs, Claudia can continue to make fiction of Esperanza's body, and by means of Esperanza's body.

Paradoxically, by being a good mother, that is, by protecting and preserving Esperanza's honor, Claudia is able to undermine the system of patriarchal control of wife and offspring that the code of honor tries to protect. In part this is possible because the system of honor in seventeenth-century Spain was so dependent upon appearances. The appearance of honor had to be carefully maintained, so that any suspicion of lack of control of one's female assets could be guarded against. For this reason, honorable women were carefully enclosed and always accompanied when they went out of their husband's or father's house. The patriarch must avoid at all cost the deadly influence of the *quedirán* (*¿qué dirán?* [what will they say?]) because any rumor could destroy his reputation.

Voyeurism and Paternity

The existence of the noun *quedirán* in Spanish indicates a link between honor and language. Claudia exploits this relationship fully, and in so doing, catalyzes the production of narrative. This is because her activities operate between the constructs of honor and dishonor; they make a space in discourse that is not definable by the necessarily exclusive terms of the system of honor. The space that she creates is a gap in the text that narrative proceeds to try to fill, to decide. In Esperanza's case, this is the paradox of a *puta honrada*, an honorable whore.

This relationship operates within, and yet does not give up power to, the dominant society. Honor and keeping up appearances are very important to Claudia, but only so that she can undermine the society that those notions support by keeping Esperanza's reputation good so that she may sell her as a virgin. For this reason, she investigates Félix "como si le hubiera de tomar por verdadero yerno" (357) ["as if she were going to take him for a real son-in-law"]. The use of the subjunctive in this quotation shows, however, the degree to which her adherence to the rules of dominant society is undermined by the constructs of her own fictive abilities. She is as attentive to the problems of honor as a birth mother or blood relation would be. In this respect, she functions as a mother, but with a twist. According to Irigaray:

> Mothers are essential to its [the social order's] (re)production (particularly inasmuch as they are [re]productive of children and of the labor force: through maternity, child-rearing, and domestic maintenance in general). Their responsibility is to maintain the social order without intervening so as to change it. Their products are legal tender in that order, moreover, only if they are marked with the name of the father, only if they are recognized within his law: that is, only insofar as they are appropriated by him.[32]

Claudia's operation as Esperanza's mother maintains the social order and marks Esperanza with the name of the father by means of her attention to the code of honor. In this way, Esperanza can be "recognized within his [the father's] law," that is, she can exist within respectable society. By careful outward observance of the

patriarchal law of honor, Claudia makes "legal tender" of Esperanza. But in a variation of recognized market practices, she upholds Esperanza's honor not so that she can be an exchange object in marriage or motherhood (two institutions controlled by men) but so that she can serve in an exchange that Claudia, a woman outside the constraints of either institution, controls.

Claudia knows how dependent these operations are on the flesh and blood of women. When Esperanza complains about the pain of needle and thread and asks Claudia to think of another way to impersonate an intact hymen, Claudia insists on the necessity of using Esperanza's body as a means to profit:

"porque no hay rústico ya que, si tantico quiera estar en lo que hace, no caiga en la cuenta de la moneda falsa. Vívame mi dedal y ahuja, y vívame juntamente tu paciencia y buen sufrimiento, y venga a embestirte todo el género humano; que ellos quedarán engañados, y tú con honra, y yo con hacienda y más ganancia que la ordinaria." (363)

["because there's no bumpkin who, if he wanted to find out, wouldn't figure out that the coin was false. Long live my thimble and needle, and with them your patience and long-suffering, and let all the world burst into you; let them remain deceived, and you with your honor, and I with my estate and more income than the ordinary."]

As this quotation shows, Claudia's goal in establishing a credible kinship with Esperanza is to get "más ganancia que la ordinaria"—the aim of her familial arrangement is to produce wealth. To this end, the wares that she is selling must appear to be authentic; Claudia needs to avoid the discovery of the "moneda falsa"—the fake coin—that is Esperanza's virginity. Coins, or money, it may be remembered, are abstractions of exchange, pure exchange value.

This is also the way that Irigaray refers to virgins:

The virginal woman, on the other hand, is pure exchange value. She is nothing but the possibility, the place, the sign of relations among men.

In and of herself, she does not exist: she is a simple envelope veiling what is really at stake in social exchange. In this sense, her natural body disappears into its representative function.[33]

Esperanza, because she is not a virgin, is definitely not legal tender in this system of exchange. But Claudia is a good counterfeiter, and her techniques, precisely, make Esperanza's natural body disappear "into its representative function." As the imitation of an abstraction, Esperanza represents fiction in the text.

Esperanza's body as subject becomes irrelevant except as an object incarnating the fictions of its users—in other words, a kind of text. Numerous allusions in *La tía fingida* cast Esperanza in the role of text. For example, at the beginning of the story, when the two students are trying to figure out who the new residents of the house are, they remember that in that edifice "siempre se había vendido tinta, aunque no de la fina" (350) ["ink had always been sold there, although not the most refined"]. Avalle-Arce's note says that "los cometaristas anteriores de *La tía fingida* . . . con quienes no discrepo, ven en esta expresión una nueva perífrasis para 'prostíbulo' " (350 n.3) [earlier commentators of *La tía fingida* . . . with whom I do not take issue, see in this expression a new periphrasis for "brothel"]. Esperanza is like ink, the agent of text-making, and like ink, she will be used (in this case, sold) to produce fiction.

She is also identified with a literary text when the students who serenade her state their requirements to a poet whom they have engaged to write a sonnet in her honor. All they ask, but they insist on it, is that the sonnet include her name: "que en todo caso incluyese la composición el nombre de Esperanza" (352) ["that in any case the composition must include the name of Esperanza"]. It is important that she be identified with text in the metaliterary articulation of desire that is not only the sonnet but also the *romance* (ballad) that follows it.

Additionally, the sonnet is the occasion of literary criticism in the text. After it is recited, a passing bachelor of laws exclaims:

[99]

"¡Voto a tal, que no he oído mejor estrambote en todos los días de mi vida! ¿Ha visto Vmd. aquel concordar de versos, y aquella invocación de Cupido, y aquel jugar del vocablo con el nombre de la dama, y aquel *implor* tan bien encajado, y los años de la niña tan engeridos, con aquella comparación, tan bien contrapuesta y traída, de *pequeña* a *gigante?* Pues ya, la maldición o imprecación me digan, con aquel admirable y sonoro vocablo de *incendio* . . . juro a tal, que si conociera al poeta que tan soneto compuso, que le había de enviar mañana media docena de chorizos que me trajo esta semana el recuero de mi tierra." (354)

["I swear, I've never heard a better ditty in all my life! Did you notice the harmony of lines, and that invocation to Cupid, and that wordplay with the name of the lady, that well placed *implore,* and the way the girl's age was brought in, with that comparison, so well opposed and worked, from *tiny* to *gigantic?* Let them curse me if I say so, but what an admirable and sonorous word is *conflagration!* . . . I swear, if I knew who was the poet who wrote such a sonnet, I would send him tomorrow a half dozen sausages that I just got this week from home!"]

Thus, the literary criticism leads to an exchange between two men, the lawyer and the poet. The lawyer is so impressed with the sonnet that he promises its maker a gustatory treat if he will meet with him. Esperanza, as text, is the occasion of exchange between men, just as Esperanza, a virgin, is—she is a repository of discourse and of desire.

After the putting into discourse of "Esperanza," Grijalba opens a window and says:

". . . Sepa, Señor mío, que no es de las que piensa, porque es mi Señora mui principal, mui honesta, mui recogida, mui discreta, mui graciosa, mui música, y mui leída y escribida, y no hará lo que Vmd. le suplica, aunque la cubriesen de perlas." (355)

[". . . I'll have you know, Sir, that she is not one of the women that you might think she is, because my Lady is very illustrious, very honorable, very secluded, very discreet, very amusing, very musical, and

[100]

very well-read and well-lettered, and she will not do what you ask, even if you would cover her with pearls."]

In the context of fending off a band of lewd wooers, Grijalba's comment that Esperanza is "mui leída y escribida" is an attempt to say that Esperanza can both read and write and is certainly not some kind of floozy. But the literal meaning of the two past participles *leída* and *escribida* is *read* and *written*—two words that explicitly identify Esperanza as a text.

When Claudia attempts to convince Esperanza to suffer again the needle and thread, she says, " '. . . y venga a embestirte todo el género humano; que ellos quedarán engañados, y tú con honra, y yo con hacienda y más ganancia que la ordinaria' " (363) [" '. . . and let the whole human race rush into you; they'll all be left deceived, and you with honor, and me with a fortune and more profit than the usual' "]. The result of Claudia's hymen mending and Esperanza's submission to the process of selling her fictive virginity is threefold: Claudia will make a good profit; Esperanza will keep her good reputation; and the whole human race, or genre (the word *género* means grammatical gender, genre, and race in Spanish), will be deceived, "engañado" by textual engaño, fiction. Claudia's excellent artifice, by means of Esperanza's body, brings together the themes of exchange, honor and fiction.

But that body, regardless of its objectification, still operates according to its own physical, not fictional, needs. Those needs will return and make themselves felt one way or another. This happens, in *La tía fingida,* immediately after Claudia's aforementioned exhortation. Esperanza has the last word—she is willing to work as a prostitute (thus her compromise idea of working as one until the fleet arrives in Sevilla), but her body cannot take the pain of mending and breaking any longer (363). With this insistence on the primacy of the body, not as an insensate repository of signification but as a bundle of blood and nerves, the argument between Claudia and Esperanza comes to an end. It terminates

not because it is finished, but because another body makes its needs felt: Félix's. Without his being able to control it, he begins to sneeze so loudly that he can be heard in the street:

> comenzó a estornudar con tanta fuerza y ruído, que se pudiera oír en la calle. (364)
> [He started to sneeze so loudly that he could be heard in the street.]

This intrusion of the body into the realm of abstraction is the destruction of Claudia's carefully constructed fiction of Esperanza's virginity. Her immediate response is to protest this disruption of her fictionalized honor:

> "¡Jesús, valme! ¿Qué gran desventura y desdicha es ésta? ¿Hombres en mi casa, y en tal lugar, y a tales horas? ¡Desdichada de mí! ¡Desventurada fui yo! ¿Y mi honra y recogimiento? ¿Qué dirá quien lo supiere?" (364)
> ["Jesus, help me! What great mishap and misfortune is this? Men in my house, and in such a place, and at such an hour? Woe is me! I was born cursed! And my honor and seclusion? What will someone who found out say?"]

Félix's response is to face facts, to dispense with fiction. He admits that he is utterly taken with Esperanza and that he arranged to hide in her room so that he could see and enjoy her at close range (364). But Claudia ignores his confession; her answer is, instead, to lament the condition of women who live without the protection of men, and to insist that Félix leave the room. Félix, however, wants to stay and guarantees both her honor and profit by offering a heavy gold chain as a deposit.[34] Grijalba grabs it and urges Claudia to accept the offer. But this only infuriates her more—not because the chain is not valuable enough but because accepting it would cause the dissolution of Claudia's fiction and her control over it. Her response is as follows:

> "¿Y la limpieza de Esperanza, su flor cándida, su puridad, su doncellez no tocada, su virginidad intacta? ¿Así se había de aventurar y vender,

Voyeurism and Paternity

sin más ni más, cebada de esa cadenilla? ¿Estoy yo tan sin juicio que me tengo de encandilar de sus resplandores, ni atar con sus eslabones, ni prender con sus ligamentos? ¡Por el siglo del que pudre, que tal no será! Vmd. se vuelva a poner su cadena, señor caballero, y mírenos con mejores ojos, y entienda que aunque mujeres solas, somos principlaes, y que esta niña está como su madre la parió, sin que haya persona en el mundo que pueda decir otra cosa, y si en contra de esta verdad le hubiesen dicho alguna mentira, todo el mundo se engaña, y al tiempo y a la esperiencia doy por testigos." (365–66)

["And the cleanness of Esperanza, her white flower, her purity, her untouched girlhood, her intact virginity? Is it to be risked and sold, without remedy, preyed upon by this bit of a chain? Am I so senseless as to be dazzled by its glitter, or to be tied in its links, or taken by its fastenings? For the sake of him who rots in the grave, it shall not be! You sir, put your chain back on, sir gentleman, and look better on us, and understand that, although women alone, we are proper, and that this girl is as her mother gave birth to her, so that no one in the world can say differently, and if against this truth someone has told you some lie, everyone is deceived, and I offer time and experience as witnesses."]

This impassioned defense of Esperanza's virginity astonishes Grijalba, who tells Claudia to keep quiet, because Félix has overheard everything. Nevertheless, Claudia insists on the fiction that she has created—that Esperanza is her niece and a virgin: " '¿Qué ha de saber, desvergonzada, qué ha de saber?' replicó Claudia. '¿No sabeis vos la limpieza de mi sobrina?' " (366). [" 'What is there to know, shameless woman, what is there to know?' replied Claudia. 'Don't you know the cleanness of my niece?' "].

She is desperate to keep the untold story untold, but the battle is already lost: too many people have learned, by eavesdropping, how Claudia constructed meaning. Having understood the process of its making, they are now able to take it apart. One by one, witnesses line up to challenge her story: first Félix, then the curious policemen who have let themselves into the house (367), then the students (368) whose desire to know Esperanza initiated

the process of Claudia's undoing. All of these interpreting presences, the reader learns, overheard the story of hymen mending at the time of Claudia's narration. Everyone—except for Claudia—has known everything all along. She is the last to understand that all the gaps have been filled—in fact, there is no evidence in that text that she ever does admit the dissolution of her fiction. Perhaps that is the reason that, in the end, she is judged a sorceress; she will not abjure faith in a reality of her own creation.

As is the case with that other *hechicera* and hymen mender, Celestina, once Claudia is removed from her ability to create hymen fiction, the hymen in question is quickly decided—one student saves Esperanza from rape by marrying her (369)—and the narrative comes to an end.

Thus, the censorious interpretation of Claudia's overheard prescription for hymen fiction is what undoes the narrative. This eavesdropping is accomplished by means of the penetration of Claudia's house by uninvited men. After Félix's spasm of sneezing,[35] Claudia voices her dismay:

"¡Ay sin ventura de mí," volvió a replicar Claudia, "y a cuantos peligros están puestas las mujeres que viven sin maridos y sin hombres que las defiendan y amparen! ¡Agora si que te echo menos, malogrado de ti, Juan de Bracamonte—no el arcediano de Xerex—, mal desdichado consorte mío, que si tú fueras vivo, ni yo me viera en esta ciudad, ni en la confusión y afrenta en que me veo! Vmd., señor mío, sea servido luego al punto de volverse por donde entró, y si algo quiere en esta su casa de mí o de mi sobrina, desde afuera se podrá negociar—no le despide ni desafucia—con más espacio, con más honra y con más provecho y gusto." (364–65)

["Oh poor me!" Claudia began to reply, "and to how many dangers are women exposed who live without husbands and without men to defend and help them! Now I do miss you, you scoundrel, Juan de Bracamonte—not the archdeacon of Jeréz—, unlucky consort of mine, because if you were alive, I wouldn't find myself in this city, or in the confusion and insult in which I see myself! Sir, my dear Sir, please leave immediately the way you came in, and if you want anything in

this house from me or from my niece, it can be negotiated outside—don't say goodbye or give up—with more space, with more honor, and with more profit and pleasure."]

A man has intruded upon the space (*lugar*) and time (*horas*) of the constellation of meaning that Claudia attempts to construct and to control. His presence there is a menace to the fiction of her *honra;* because some watcher or listener who is not under her control has entered the scene, her fiction runs the risk of being written over, or retold: "¿Qué dirá quien lo supiere?"—an unwelcome commentarist has entered the realm of the text ["What would someone say if they found out?"].

The invasion of her fiction is described in terms of the architectural metaphor of the house (*casa*). It may be useful to recall that the house was the first thing to catch the eyes of the libidinous students whose desires begin the narrative. Specifically, it is a novelty about the appearance of the house that draws their attention:

... vieron en una ventana de una casa y tienda de carne una celosía, y pareciéndoles novedad, porque la gente de la tal casa, si no se descubría y apregonaba, no se vendía, y queriéndose informar del caso, deparóles su diligencia un oficial vecino. . . . (349)

[. . . they saw in a window of a house and flesh shop a lattice-blind, and, it seeming to them to be a novelty, because the occupants of such a house, if they do not expose and advertise themselves, cannot sell themselves, and wanting to find out about the situation, they asked a neighboring man. . . .]

This matter is similar to one in *Casamiento engañoso:* Estefanía appears to be a prostitute, yet she is veiled and modest. Likewise, the students know that this was a house of ill repute; yet on their perambulation they discover that the window in which its former occupants displayed themselves for sale is now veiled with blinds. Vision is blocked; the voyeurism that attends prostitution is thwarted; the aperture by means of which the quality of the in-

habitants could be seen and determined is covered with a *celosía*, making any intercourse between inside and outside problematic. The window, because of the blind, ceases to be a place for conversation between inside and outside, no longer functions as an avenue for penetration.

Architecturally, a window is the element of a building that is least decidable. It is neither inside nor outside the building, and (whether glazed or not) it can be transparent, a place for looking out and in. Unlike a door, though, it limits the transit of human bodies between the inside and the outside; the senses may use it as a vehicle for perception, but the body itself does not pass through it except in extraordinary, rule-breaking circumstances (burglary, escape, suicide). It is, rather, specifically useful to the sense of sight. The window alludes to the potential of passage between inside and outside; the door is the fait accompli of that passage. For these reasons, the window becomes an architectural locus of desire, and the *celosía* is made to function as a hymen in that locus.

Initially, the students are inflamed with lust as a result of the information that the neighbor gives them about what is behind the blinds; then the text describes the boys as "deshollinadores de cuantas ventanas tenían albahacas con tocas" (349–50). Avalle-Arce's note explains that this means "investigators of any windows that had bonneted basil plants" (349 n.2). Since basil plants were then (as now) commonly seen at Spanish windows, as were women, the phrase "albahaca con toca" came to mean "a woman." But close attention to the sentence shows that the object of the students' desire is not the *albahacas* but rather the window (*ventana*) itself: they are "deshollinadores de ventanas." It is the definition, or investigation, of that space between that is the goal of their lust.

For this reason, the students decide to mount a serenade: its goal is, in the middle of the night, to bring the desired woman to a window where she may be seen. As I have noted, the serenade begins with music and the recitation of the Esperanza sonnet. But this attempt is fruitless: "A todo lo cual se estaban las ventanas

de la casa cerradas, como su madre las parió" (354) [The windows were as closed as their mother gave birth to them]. The sense of pristine originality that accompanies the closed windows is illustrated by a phrase that is used to describe the virginity of a woman. As that phrase frames the meaning of a woman's body in terms of a patriarchal signifying system, so do the students ("esperantes machegos," expectant Manchegans) hope to frame Esperanza within their expectations of what is supposed to happen in the structure that they load with meaning: the window. They are trying to situate her in a hymen construct.

They redouble their efforts with another literary sally, this one the *romance* that again incarnates Esperanza's name (354–55). As a result of this, "Sintieron abrir la ventana"—they hear the window open, and then they see one of the *dueñas,* who speaks to them in a sharp and polished voice—"una voz afilada y pulida." The senses of sight and hearing are emphasized in this fenestration, which provides a window on the operations of desire. Sight and hearing, it may be remembered, are the two senses that dominate the child's first apprehension of the primal scene. In that scene, there is another person between the child and his love object. In this case, the *dueña,* Grijalba, is that person between who upsets and frustrates the fantasy.

One of the suitors begs Grijalba to ask doña Esperanza to present herself at the window, "que se ponga a esa ventana, que la quiero decir solas dos palabras, que son de su manifiesta utilidad y servicio" (355) ["that she would put herself at the window, because I want to say only two words to her, which are to her manifest usefulness and service"]. He wishes to initiate conversation with Esperanza, but Grijalba prohibits it because Esperanza is already "mui leída y escribida"—her text is already constructed—the window must not frame her, and the suitor's two words must not adulterate her text.

Because of the absolute control that Claudia exercises over her, Esperanza is not accessible to the men who would like to frame her in their own meaning system. No matter what they do, the window remains covered with the lattice-blind, and no one, now

not even Grijalba, appears. As a result of their frustration, want to stone the house, smash the *celosía,* and end it all with a tin-pan serenade:

> Enfadados y corridos todos, quisieron apedrealle la casa, y quebralle la celosía, y darle una matraca o cantaleta: condición propia de mozos en casos semejantes. (356)
>
> [Every one of them angry and flustered, they wanted to stone the house, and smash the lattice-blind, and give her (Grijalba, or Esperanza) a tin-pan serenade: which is what any guy would do in a similar situation.]

In other words, if they cannot get satisfaction from the construction, they will destroy it and drown out its significance in a tumult of meaningless noise.

It takes time, but this is precisely what happens in and to *La tía fingida.* As a result of Claudia's refusal to put Esperanza into somebody else's frame of reference—her refusal to part with the fiction that she constructs (that is, that Esperanza is an honorable virgin)[36]—the men who seek Esperanza abandon the intolerable undecidability of the window and break down the door of her house. First, Félix comes in through the door and spies and eavesdrops. Then, the embodiment of the dominant order, the police, "desquiciaron la puerta" [unhinged the door]—that is, permanently opened it—and sneaked into the house so that they, too, could overhear Claudia's discourse.

The idea of an honorable woman living in a house of ill repute poses an intolerable variation and question before the logic of patriarchal structures. Esperanza as intact non-virgin, referring to herself, asks the question, "¿Ser ángel en la calle, santa en la iglesia, hermosa en la ventana, honesta en la casa, y demonio en la cama?" (362) ["Being an angel in the street, a saint in church, pretty in the window, decorous at home, and a demon in bed?"]. In describing her role in the text, she does not allude to herself with any pronoun or name; as a subject, she is absent; she is, instead, the articulation of the projections of people who interpret her according to their own needs and desires. Perhaps this ac-

counts for her name—literally, hope. Hope is a function, that, like desire, is posited upon lack. It can exist only without its fulfillment—and until that fulfillment, it postulates an infinite set of possibilities. Because of the tension that develops between the possibilities of satisfaction and of disappointment, it is intolerable to hope for too long. Hope, Esperanza, makes for a situation of multiple and mutable signification and projection; that is, another hymen that must be decided.

The question that Esperanza asks must be answered, and the gap filled, if the dominant order is to remain in power of meaning. For this reason, the police must take Claudia outside the walls of her house of fiction, and Esperanza must be wed. Deciding a hymen, in these cases, means deciding which man may write his name upon it, in the courts or in matrimony. But the system of relations that I have described within the text is applicable also to what has occurred outside it, in scholarly readings and writings. The voyeurism and concerns of kinship that regulate desire within *La tía fingida* apply, as well, to the strange serenade of criticism to which the work has been subjected. In this criticism, voyeuristic pleasure in detailed reading of the text combines with an urgent need to write the name of a man over it—to establish its legitimacy or illegitimacy, to give it Cervantes's name, or to disassociate it from him.

This is because the text explicitly problematizes hymen mending, and then (intolerably) functions as a mended hymen itself. It is a product of artifice that is outside the jurisdiction of dominant meaning systems because it bears no name, and like a hymen, it is undecidable. Regardless of its paternity, or location in a patriarchal order, the coincidences surrounding the existence of the text (its uncertain manuscript tradition, its link with arch-canonical Cervantes texts, its relentless anonymity) have made it both intriguing and intolerable to scholar-readers. Its repression, persistent return from repression, and deviant centrality point towards the possibility that the fictive element in literary texts may have an unrecognized sibling in critical texts, as well.

CHAPTER 6

Convivencia and Difference: The Untold Story in *Libro de buen amor*

The three works examined in this study were written in Spain during a period of imperialism abroad and societal homogenization at home. Fourteen ninety-two, the so-called *annus mirabilis*, was miraculous not only because Columbus claimed a new world for Spain but also because it marked the end of the reconquest—Granada, the last Muslim realm on the peninsula, fell to Ferdinand and Isabella in that same year.

This moment coincided with the impetus, manifested through the Reyes Católicos [Catholic kings], to establish orthodoxy in Spain. Having created an unprecedented degree of territorial unity by bringing together the various Christian kingdoms on the peninsula, and by conquering the last Moorish stronghold, they now sought to establish religious uniformity as well. Immediately, expulsions of Jews and Muslims began to occur. The succeeding century saw the rise of the power of the Inquisition, whose primary goal was to maintain regularity of Catholic faith and practice among the large population of new Christians. By the beginning of the seventeenth century, with Philip III on the throne,

further conflict with Jews and *moriscos* came to an end with the final expulsions of 1609–10.

La Celestina, published in 1499, was written just as the deadly effect of these policies was beginning to be felt. At the time of the publication of *Casamiento/Coloquio* (1613), the programs of expulsion and control had been carried out to their fullest. *La tía fingida,* judging from the date of the Porras manuscript (ca. 1604–6),[1] also pertains to this epoch. The untold story in each of these texts had been forced underground by the ever-increasing landslide of orthodoxy and the persistent desire to eradicate difference. The importance of the deviant woman character to the narrative, in terms of her function as maintainer of *différance* and undecidability, is overshadowed in these texts by the need to punish her for her necessary subversion. She becomes an emblem of controllable difference—subversive but extinguishable. What happens to Celestina, Claudina, Estefanía, Cañizares, Camacha, Montiela, Esperanza, and Claudia is emblematic of what happens to heterodoxy in Golden Age Spain.

But it should be recalled that these characters have their origin in a work composed around 1343, in a more tolerant epoch, when much of Christian Spain enforced the laws of Alfonso X, el Sabio's *Partidas,* a law code that permitted the exercise of their religion and commerce by Muslim and Jewish subjects. The Muslim political rulers of the time, too, were tolerant of their Christian and Jewish subjects. This *convivencia* of three faiths, although not free of bias (people of subordinate faiths had to pay extra taxes, live in separate quarters of a city, distinguish themselves by dress, etc.) created a situation of cultural and religious exchange unprecedented in Europe. The peninsula was an entity of three religions and of many languages.

In the midst of this confluence, *Libro de buen amor,* by Juan Ruíz, Arcipreste de Hita, appeared. *Libro de buen amor* is important to the purposes of this study because a central character, Trotaconventos-Urraca-buen amor,[2] provides the model for Celestina and for the characters whose portrayal she influences in *Casamiento/Coloquio* and *La tía fingida.*

Convivencia *and Difference*

Like her descendants, Trotaconventos is integral to the production of the narrative of *Libro*. The narrator announces that his poem will illustrate *buen amor*—good love—and that as a representative of the church his purpose in telling his bawdy story is to help his audience to swallow the lesson he will teach—but with a spoonful of sugar. As a result, the poem is a collection of ribald anecdotes about desire, lust, and sensuality. The narrator pursues and is pursued by various women throughout the book but meets with his greatest success in the poem's final series of seductions (sts. 1317–1578)[3] because he enlists the aid of the go-between, Trotaconventos.

Unlike the texts that are influenced by it, *Libro de buen amor* acknowledges the complicity of this character in its production. This occurs most explicitly in stanzas 932 and 933, in which Trotaconventos, in dialogue with the narrator, is telling him what to call her:

"Nunca diga[de]s nonbre malo nin de fealdat,
llamatme 'buen amor' e faré yo lealtad,
ca de buena palabra págase la vecindat:
el buen dezir non cuesta más que la neçedat." (932)

["Never say an ugly name or bad,
call me 'buen amor' and I'll be loyal to you,
because though everyone would pay for a good word:
good talking costs no more than foolish."]

The *vieja* (old woman) instructs the narrator to call her "buen amor." Since he assents to this in the next stanza, the number of names that she has in the text rises to three: *Trotaconventos, Urraca,* and *buen amor*. This plurality of names helps to show the elasticity and arabesque, unfixed quality of the discourse of *Libro de buen amor*.[4] The *vieja* go-between has several names and moves effortlessly from one signifier to another. That she insists on the name *buen amor* emphasizes the degree to which she cannot be fixed in definition. Countless pages of criticism have been written about the meaning of *buen amor* in the poem's title and in the text

[113]

itself, despite the fact that *buen amor* is the original undecidable in Spanish literature. The function of the text depends not on ascertaining the precise meaning of *buen amor,* or whether its tone is moralizing or ironic, but, rather, on the free play of the multiple meanings of that phrase in the text. Trotaconventos–Urraca–buen amor incarnates this free play in the text—what are important are her agency, her function, her movement in the economy of desire. She is present in, and as, text, for the love of it:

> Por amor de la vieja e por dezir razón,
> "buen amor" dixe el libro e a ella toda saçon;
> desque bien la guardé, ella me dio mucho don:
> non ay pecado sin pena nin bien sin gualardón. (933)

> [For love of the old woman and to tell the truth,
> I called her and the book "buen amor" simultaneously;
> Since I was kind to her, she gave me many favors:
> There is no sin without penalty, and no good deed without reward.]

She and the text exist consubstantially in an atmosphere of goodwill.

Like the later texts that this study examines, *Libro de buen amor* ends when the old woman dies. The narrator is explicit about this connection:

> yo, con pesar grande, non puedo dezir gota
> porque Trotaconventos ya non anda nin trota. (1518)

> [I, from heavy sadness, can not say a drop
> because Trotaconventos neither ambles now nor trots.]

The narrator's statement "non puedo dezir gota" is not just hyperbole: his narrative and his ink have run out because of Trotaconventos's death. Her slippery agency as erotic and linguistic go-between is integral to the production of narrative; without her, it ceases.

After her death, orthodoxy begins to appear in the text. Its last stanzas, which follow immediately the narrator's epitaph to Tro-

Convivencia *and Difference*

taconventos-Urraca-buen amor, consist of moralizing on the spiritual armament necessary to a Christian; on the evils of women; mention of a useless errand boy who only makes the narrator miss his *vieja* more; and finally, eighteen stanzas on "como dize el Arcipreste que se ha de entender este su libro" (1626) [how the Archpriest says that this his book should be understood]. In other words, after the death of *buen amor,* the narrative dries up, and the need to define it, to fix its meaning, sets in.

Like her daughters, Trotaconventos, too, dies in the service of the narrative. (*Libro de buen amor* was composed, after all, in a patriarchy in which women are use objects for production and reproduction.) But her agency in the making of narrative, as a freely moving signifier of desire (*buen amor*) is acknowledged in the text. The elasticity of meanings in *Libro de buen amor* has been attributed to the fact of its production in a milieu in which the three religions of Spain liberally interpenetrated each other, and in particular to the fact that Islam, unlike Christianity, did not construct a body/spirit opposition.[5] In this text, sensuality and religion are not locked in conflict. Rather than enforcing oppositions, *Libro de buen amor,* by means of Trotaconventos-Urraca-buen amor, explicitly works between them, positing undecidability as an aesthetic desideratum.

One of the explanations of *buen amor* is that it is a love-concept imported from the Cathars, perhaps via the mythical Banu-Udra tribe of North Africa. For them, *buen amor* was physical desire fanned to its greatest heat, but not brought to climax. All variety of sexual stimulation is permitted, but perferably not the consummation that would bring an end to desire. Not filling the hole that is desire is thus integral to *buen amor,* just as it is to the untold story, whose forerunner is the multiple-meaning gap that is Trotaconventos-Urraca-buen amor in *Libro de buen amor.*[6]

Such a concept of *buen amor* could exist only in an epoch of *convivencia* [living with] like that in which *Libro de buen amor* was composed. This *convivencia* could also be conceived of as a linguistic construct that describes, in positive terms (in contrast to the negative terms—setting apart and setting aside—of "differ-

ance"), a place in language where meanings simultaneously coexist without contradiction. In fact, *convivencia* posits a discourse economy in which contradiction is an irrelevant term, an inapplicable concept, because in *convivencia,* difference does not necessitate discourse against, through, or over. Such *convivencia* is perhaps most explicit in the inclusion of Arabic words and allusions in the midst of the elastic Spanish of the text. The language of the poem twines between cultures and concepts that a later epoch will force into opposition.

Fourteen ninety-two, the year of the conquest of Granada and the discovery of the New World, was also the year in which Antonio de Nebrija published the first standard grammar of Spanish (it was the first written grammar of any Romance tongue), and established orthodoxy in language. Trotaconventos-Urraca-buen amor, restricted by a new orthodoxy in social structures, religion, and language, became by 1499 the witch-bawd Celestina. Instead of being, herself, hymen in the text, she mends and unmends hymens as a means of maintaining undecidability. Her function is still integral to the text, and still emblematic of the function of difference as catalyst and subverter of narrative. But her manifestation can no longer be explicit, because *convivencia* has disappeared, or because, under pressure, it has metamorphosed into "différance." The untold story in these texts thus marks the unreadable trace of both a social and a linguistic *convivencia* in internal exile; a function in discourse that tells untelling itself, like the new Christians who, straddling oppositions of orthodoxies, *"vivían desviviéndose,"*[7] lived unliving themselves in a culture that had ceased to value difference.

Notes

Chapter 1

1. Paul Julian Smith's *Writing in the Margin: Spanish Literature of the Golden Age* (Oxford: Oxford University Press, 1988) calls itself "the first study of writing in the Spanish Renaissance or Golden Age to draw extensively on what has become known as 'post-structuralism' " (1). His introduction harmonizes with many issues I raise in mine.

2. Jon Stratton's *The Virgin Text* (Tulsa: University of Oklahoma Press, 1987) suggested the terminology *fetishized feminine object* in relation to a literary text. Stratton argues that readers like to plow through fresh, new novels as if the books were virgins. His argument is based on Marxist theories of consumerism, on the allure of ownership of the *new* in a capitalist society.

3. The theory behind this, as well as the constellation of meaning for the word *detail*, was suggested by Naomi Schor's "Female Paranoia: The Case for Psychoanalytic Feminist Criticism" in *Breaking the Chain: Women, Theory, and French Realist Fiction* (New York: Columbia University Press, 1985).

Chapter 2

1. Although the province of this discussion will be writing that styles itself according to the traditions of narrative (and possibly poetic)

art, I do not wish to exclude any form of writing from these explorations. For that reason, I take *text* to mean a set of one or more written words.

2. Gérard Genette, *Narrative Discourse: An Essay in Method*, trans. Jane E. Lewin (Ithaca: Cornell University Press, 1980), 52.

3. Gérard Genette, *Figures of Literary Discourse*, trans. Alan Sheridan (New York: Columbia University Press, 1982), 165. Very recently it has come to my attention that Mieke Bal notes this passage (and another that I cite in chap. 2, n. 68) from *Narrative Discourse*, to an effect that parallels this study's, in *Lethal Love: Feminist Literary Readings of Biblical Love Stories* (Bloomington: Indiana University Press, 1987), 91–95. Bal, too, sees the displaced character as significant in narrative.

4. Iser quotes Ingarden's German neologism in Wolfgang Iser, *The Act of Reading: A Theory of Aesthetic Response* (Baltimore: Johns Hopkins University Press, 1978), 170.

5. Roman Ingarden, *The Literary Work of Art: An Investigation on the Borderlines of Ontology, Logic, and Theory of Literature*, trans. George G. Grabowicz (Evanston: Northwestern University Press, 1973); and Iser.

6. Ingarden, 249.

7. Ingarden, 252. It is important to note, as will be further explained in this chapter, that Ingarden and Iser have a conception of indeterminacy that in some respects differs from what I am calling the untold. They trivialize the spot of indeterminacy as that which is, "simply, not specified in the text; for instance, is 'the table' three-legged or four-legged? Made of oak or plastic?" They limit the examples of gap filling to seemingly insignificant spots in the text. But the mechanics of reading that they describe in relation to the reader's approach to spots of indeterminacy applies to the reader's approach to the untold story, as gap, as well. The gap that is the untold story is significant in its indeterminacy—or, rather, despite the reader's efforts to ideate in it, it exists without respect to a patriarchal reading economy that depends upon the determination of gaps—whether they be spots of indeterminacy, or traces of the untold. The untold thus "subverts the whole notion of being able to fill in a missing element of meaning," although, at the same time, it is integral to the production of the narrative in which it makes itself felt. [I am indebted to Ross Chambers for asking me to clarify this point and for supplying the lucid phrases I have quoted here.]

8. Ingarden, 252–53.

9. Ingarden, 251.
10. Ingarden, 248.
11. Iser, 197.
12. Iser, 206.
13. Alice Jardine, *Gynesis: Configurations of Woman and Modernity* (Ithaca: Cornell University Press, 1985), 98.
14. Iser, 169.
15. Iser, 169.
16. Jardine's commentary on Freud's President Schreber case is a helpful accompaniment to this discussion; Jardine, 98.
17. Iser, 189.
18. Iser, 167.
19. Iser, 225–26.
20. Iser, 226. For Sartre's analogy see Jean-Paul Sartre, *What Is Literature?*, trans. Bernard Frechtman (Gloucester, Mass.: Peter Smith, 1978), 18–19.
21. Iser, 228.
22. Iser, 229.
23. Iser, 226.
24. Iser, 190–91.
25. For instance, in her article "Narrative Gaps/Narrative Meaning," *Raritan*, October/November, 1986, 86, Millicent Bell says: "Ellipses so destructive of the fictions they inhabit threaten our confidence in the meanings which the preceding text has labored to produce and seem to threaten meaning altogether, leaving behind only, at best, an existential acquiescence."
26. Susan Rubin Suleiman, *Authoritarian Fictions: The Ideological Novel as a Literary Genre* (New York: Columbia University Press, 1983), 237.
27. Roland Barthes, *Le plaisir du texte* (Paris: Editions du Seuil, 1973), 19; trans. Richard Miller, *The Pleasure of the Text* (New York: Hill and Wang, 1975), 9–10.
28. Juliet Mitchell in Jacques Lacan, *Feminine Sexuality*, trans. Jacqueline Rose, ed. Juliet Mitchell and Jacqueline Rose (New York: W. W. Norton, 1982), 6–7.
29. Mitchell in Lacan, *Feminine Sexuality*, 6.
30. Jacqueline Rose in Lacan, *Feminine Sexuality*, 32.
31. Terry Eagleton, *Literary Criticism: An Introduction* (Minneapolis: University of Minnesota Press, 1983), 166.
32. Mitchell and Rose in Lacan, *Feminine Sexuality*, 7, 26.
33. Jardine, 88.

Chapter 3

1. Fernando de Rojas, *Tragicomedia de Calisto y Melibea (La Celestina)*, ed. Dorothy S. Severin (Madrid: Alianza, 1979). Henceforth all parenthetical references in my text refer to this edition. The English translations are in some cases taken verbatim from *Celestina*, trans. Mack Hendricks Singleton (Madison: University of Wisconsin Press, 1958), but in most instances I have adapted Singleton's more aesthetically pleasing translations so that the English reader may apprehend the literal meaning of the Spanish. There is also an English translation by Lesley Byrd Simpson (*The Celestina: A Novel in Dialogue*, Berkeley: University of California Press, 1971), but this is of only the sixteen-act *comedia*. Many scholars improvise upon James Mabbe's classic 1631 English translation, *The Spanish Bawd*, which, despite the fact that it strays often from the original, captures its rhythm and mood. J. M. Cohen's translation, of the same title (Harmondsworth: Penguin, 1964), is also entertaining and useful, and truer than Mabbe's to the Spanish wording.

2. María Rosa Lida de Malkiel's monumental *La originalidad artística de La Celestina* (Buenos Aires: EUDEBA, 1962) provides the most ample study of the generic tradition from which *Celestina* arose (37–49). In addition to examining its renaissance precedents, she finds inspiration and sources for the text in Roman comedy. For more on the sources, as well as for another encyclopedic, if in parts dated, treatment, see Marcelino Menéndez y Pelayo's comments in *Orígenes de la novela*, vol. 3 (Madrid: Bailly-Baillière, 1905–10). For specifically renaissance elements, see P. G. Earle, "Love Concepts in *La cárcel de amor* and *La Celestina*," *Hispania*, 39 (1956): 92–96.

3. A little later in this chapter I will discuss the controversy surrounding the genre of *La Celestina*.

4. Alan Deyermond summarizes this effect of the text in *Historia y crítica de la literatura española*, 8 vols. (Barcelona: Editorial Crítica, 1980), 1:485–86, but the ideas are more fully developed in Stephen Gilman's *The Art of La Celestina* (Madison: University of Wisconsin Press, 1956), 147–53; see also Vicente Cano, "La función dramática del engaño en la *Celestina*," *Kanina* (Costa Rica) 8 (1984): 77–82.

5. Deyermond's study *The Petrarchan Sources of La Celestina* (Oxford: Oxford University Press, 1961) establishes the Petrarchan background of much of Rojas's work. Gilman, in *The Spain of Fernando de*

Rojas: *The Intellectual and Social Landscape of* La Celestina (Princeton: Princeton University Press, 1972), 369–70, reads the Petrarchan sources as a way to provide an existentialist view of the text. Additionally, there is the anonymous *Celestina comentada,* discussed by P. E. Russell in his "El primer comentario crítico de *La Celestina*: cómo un legista del siglo XVI interpretaba la *Tragicomedia*" in *Temas de* La Celestina *y otros estudios* (Barcelona: Ariel, 1978), 293–322, which makes ample reference to Petrarchan sources.

6. Because so much has been written about *La Celestina,* in the discussion that follows I make no attempt at an encyclopedic review of the criticism. What I will do is to show how some of the canonical critics of the text have chosen to read it, and what tendencies have developed in the rhetoric and metaphors of readings established by these established critics.

Valuable bibliographies of work on *La Celestina* have been published by Adrienne Schizzano-Mandel, La Celestina *Studies: A Thematic Survey and Bibliography,* 1824–1970 (Metuchen, N.J.: Scarecrow Press, 1971); and by Joseph T. Snow, ed., "Un cuarto de siglo de interés en *La Celestina,* 1949–1975: documento bibliográfico," *Hispania* 59 (1976): 610–60. Continuing supplements are published in the journal *Celestinesca,* May, 1977, to the present. Finally, in addition to the studies listed in these notes, a fundamental bibliography of *Celestina* studies would include, at its genesis, Menéndez y Pelayo's work in his edition of the *Celestina* (Vigo: E. Krapf, 1899) and in *Origenes.*

7. Much study has also been devoted to sources, but it has not provoked the furor that the other categories of work have, perhaps because verbatim sources from which the author(s) borrowed have been found. See Deyermond, *The Petrarchan,* for further bibliography.

8. Jerry R. Rank concurs to an extent with this opinion in his "Narrativity and *La Celestina*" in *Hispanic Studies in Honor of Alan D. Deyermond: A North American Tribute,* ed. John S. Miletich (Madison: Hispanic Seminary of Medieval Studies, 1986), 235–46.

9. Juan de Valdés, *Diálogo de la lengua,* ed. José F. Montesinos (Madrid: Espasa-Calpe, 1969), 182–83. Other early readers of *Celestina* are listed in Maxime Chevalier, *Lecturas y lectores en la España del siglo XVI y XVII* (Madrid: Turner, 1976), 138–66. They include, among others, Pedro Fernández de Villegas, Fr. Francisco de Osuna, Fr. Antonio de Guevara, Fr. Juan de Pineda, Francisco López de Ubeda, Baltasar Gracián, and Cervantes's brief mention in an introductory poem to *Don*

Quijote. See also Russell, "El primer comentario . . ." in *Temas,* 293–322.

10. *Tragicomedia,* ed. Severin, 257 n. 2.

11. *Tragicomedia,* ed. Severin, 36 and 257 n. 3.

12. Lida de Malkiel is a voice that resists "nuestra concepción actual de la individualidad casi biólogica de la creación y la obra artística" (25) [our contemporary conception of the almost biological individuality of creation and of the work of art], suggesting that the obsession with naming one author is a reflection of "la aspiración unitaria de la crítica neoclásica" (n. 14) [the unifying aspirations of neo-classical criticism] and that, to her knowledge, no one ever raised authorship as a problem before Leandro Fernández de Moratín did in his *Origenes del teatro español* (Madrid, 1830). (See Lida de Malkiel, 25 and n. 14.) Because of her influence, and because of Gilman's emphasis on Rojas's historical moment, since 1972 interest in the authorship question has waned.

13. See *Tragicomedia,* ed. Severin, Introducción and Notas.

14. Lida de Malkiel represents arguments that place *La Celestina* in dramatic genres, 27–78; Gilman in *The Art* sees the text vacillating between the two genres, 194–206.

15. *Celestina,* ed. Singleton, 284.

16. Marcel Bataillon, La Celestine *selon Fernando de Rojas* (Paris: Didier, 1961); Schizzano-Mandel, 184.

17. Lida de Malkiel, 288–315.

18. A *converso* [convert] was a Jew or Muslim who submitted to Catholic baptism, sometimes in order to be able to remain in Spain and to keep his or her material goods. The term can refer to converts from either Islam or Judaism but most often is used for converts from Judaism. The Inquisition persecuted *conversos,* and their descendants (*cristianos nuevos,* or new Christians), whom it accused of nominal Christianity and of continuing to practice Jewish (or Muslim) rites after conversion. Américo Castro was the first scholar fully to articulate the historical and cultural extremities under which *conversos* lived, in his landmark *España en su historia* (Buenos Aires, 1948). He develops these ideas, with special relevance to *Celestina,* in La Celestina *como contenida literaria: castas y casticismos* (Madrid: Revista de Occidente, 1965). Gilman builds on Castro's work, basing his comments on much archival work, in *Spain.*

19. Among the towns and cities suggested are Talavera de la Reina,

Sevilla, Salamanca, and Toledo. For an introduction to the problem, see Russell, "The Art of Fernando de Rojas," *Bulletin of Hispanic Studies,* 39 (1957): 160–67; he refuses to pick a specific spot; and Carmen Bravo-Villasante and Higinio Ruíz, "Talavera de la Reina ¿lugar de acción de *La Celestina*?", *Actas del II Congreso Internacional de Hispanistas* (Nijmegen, 1967), 529–41.

20. Miguel de Cervantes, *Don Quijote de la Mancha,* ed. Martín de Riquer (Barcelona: Juventud, 1971), 2 vols., 1:32. The technique of "versos de cabo rato" is explained 1:27 n. 1.

21. Américo Castro originated the concept of "vivir desviviéndose" (to live unliving oneself) to describe the alienating circumstances of *conversos* in Golden Age Spain. See his *La realidad histórica de España,* 3d. ed. (Mexico City: Porrúa, 1966), 80–81.

22. Conversation with Michael Berthold, Summer 1984.

23. In addition to the book-length studies previously cited, see also Michael J. Ruggiero, "*La Celestina*: Didacticism Once More," *Romanische Forshungen* 82 (1970): 56–64.

24. Ruggiero, *The Evolution of the Go-Between in Spanish Literature through the Sixteenth Century* (Berkeley: University of California Press, 1966).

25. Jacques Joset, Introducción, in Juan Ruíz, Arcipreste de Hita, *Libro de Buen Amor,* ed. Joset (Madrid: Espasa-Calpe/Clásicos castellanos, 1974), 1:xxx.

26. See Christine J. Whitbourn, *The "Arcipreste de Talavera" and the Literature of Love* (Hull: University of Hull Press, 1970), 23. Also E. Michael Gerli, *Alfonso Martínez de Toledo* (Boston: Twayne, 1976).

27. Gilman, *The Art,* 26–31.

28. Henry Charles Lea, *A History of the Inquisition in Spain,* 4 vols. (New York: Macmillan, 1906–7), 2:1. This monumental work is still the definitive history of the Spanish Inquisition and is the primary source for more recent works on the subject. Some of Lea's cultural inferences and commentaries are disputed by other historians, but his archival work is encyclopedic, and his factual data are beyond reproach.

29. Lea, 2:569. Despite this zeal, up until 1793, when it was forbidden in its entirety, *La Celestina* suffered only partial censorship from the Holy Office (Schizzano-Mandel, x).

30. "Haereticus animal pestilentissimum est: quamobrem punire debet antequam virus impietatis evomat, forasque projiciat." Diego de

[123]

Simancas, bishop of Zamora, *De Catholicis Institutionibus* (Valladolid, 1552; Venice, 1573; Rome, 1575; Ferrara, 1692). Quoted in Lea, 2:1, n.1.

31. María del Pilar Oñate, *El feminismo en la literatura española* (Madrid: Espasa-Calpe, 1938), 83–84.

32. Lea, 4:152.

33. Gilman, *Spain,* 111–266.

34. Boston Women's Health Book Collective, *The New Our Bodies, Ourselves* (New York: Simon and Schuster, 1984), 446.

35. Menéndez y Pelayo, *Historia de los heterodoxos españoles,* 2 vols. (1882; reprint, Mexico City: Editorial Porrúa, 1983), 1:403.

36. John C. Traupman, ed., *The New College Latin and English Dictionary* (New York: Bantam Books, 1966). Henceforth, definitions of Latin words in the text are from this edition.

37. Menéndez y Pelayo, *Historia,* 1:381.

38. This is true despite the fact that "las *Partidas,* sin embargo, no se promulgaron hasta 1348, en época de Alfonso XI . . . y del Arcipreste de Hita." [the *Partidas* were not promulgated until 1348, in the epoch of Alfonso XI . . . and of the Arcipreste de Hita.] Margarita Peña, introduction, *Antología,* works of Alfonso X, el Sabio (México City: Editorial Porrúa, 1973), xxv.

39. *Convivencia* literally means "living with," and refers to the sociopolitical system, in pre-Inquisitorial Spain, by which Jews, Muslims, and Christians coexisted in relative peace, without the imposition of one order over another's religious beliefs, regardless of which faith held political power.

40. Henry Kamen, *Inquisition and Society in Spain* (London: Weidenfeld and Nicolson, 1985), 15.

41. Kamen, 13.

42. Lea, 4:192.

43. Menéndez y Pelayo, *Historia,* 1:386–88; Lea, 4:192.

44. Lea, 4:192.

45. Lea, 4:193–94.

46. Gilman, *Spain,* 269–75.

47. Lea, 1:193.

48. Pennethorne Hughes in Thomas S. Szasz, M.D., *The Manufacture of Madness* (New York: Harper and Row, 1970), 83.

49. Szasz, and quote from Jules Michelet, 83. The classic study of sorcery in *La Celestina* is Russell's "La magia, tema integral de *La*

Celestina," in *Temas,* 243–76. Russell was the first critic to advance the thesis that Celestina's magical activities, in particular the *philocaptio* by which she enchants Melibea, have a "real" causal effect in the text and in the minds of Rojas's readers—in other words, that her magic is efficacious and that it enhanced the verisimilitude of the text. Yet Russell overlooks the fact that Celestina as *hechicera* is not (only?) a demonic instrument. He sees the character only as a witch and not in her historical context as wise woman. Her sorcery is intimately linked with her healing arts, her cosmetics sales, her seamstress business and her hymen mending.

Rosario Ferré's article *"Celestina* en el tejido de la *cupiditas," Celestinesca* 7, no. 1 (May, 1983), 3–16, discusses the importance of thread and fabric imagery as connection between plot, writing and the theme of *loco amor* in the text.

50. Kamen, 209.

51. Lea, 205, 206–7; 239; Mary Daly, *Gyn/Ecology: The Metaethics of Radical Feminism* (Boston: Beacon Press, 1978), 178–222.

52. Sebastián de Covarrubias y Orozco, *Tesoro de la lengua castellana o española* (1611; reprint Madrid: Turner, 1970), 401.

53. Javier Herrero, "Celestina: The Aging Prostitute as Witch," *Aging in Literature,* ed. L. and L. M. Porter (Troy, Mich.: International Book Publishers, 1980), 31–47.

54. Szasz, 105.

55. Szasz, and quote from Christina Hole, 86.

56. As José Antonio Maravall illustrates in *El mundo social de* La Celestina (Madrid: Gredos, 1964), the lower-class characters of the text participate in a subversion of the economic structures that control them: the servants rebel against their masters as a cash economy displaces the old order. The opportunities afforded by the new economy are eagerly taken up not only by Celestina, but also by Elicia and Areusa; see Catherine Swietlicki, "Rojas' View of Women: A Reanalysis of *La Celestina," Hispanófila* 85 (September, 1985): 4–5.

57. Heinrich Kramer and James Sprenger, *Malleus Maleficarum,* ed. the Rev. Montague Summers (1484; reprint, New York: Dover, 1971), 47.

58. Gilman, *The Art,* 129: "Celestina is a mistress of space as well as of the human soul"; 130–31. For a structuralist reading of space in the text and how its use relates to the action of feminine characters, see Consuelo Arias, "El espacio femenino en tres obras del medioevo es-

pañol: de la reclusión a la transgresión," *La Torre,* 1, nos. 3–4 (1987): 365–88. A more general treatment of space is Halina Czarnocka's "Sobre el problema del espacio en la *Celestina,*" *Celestinesca* 9, no. 2 (1985): 65–74.

59. Lea, 4:208–9.
60. Herrero, "Aging," 46.
61. For a goodly number of these, see, e.g., Pierre Alzieu, Robert Jammes, Yvan Lissourges, eds., *Floresta de poesías eróticas del siglo de oro* (Toulouse: France-Ibérie Recherche, 1975), especially poems 45, 77, 76, 46, 130, 89, 81. In at least four from this collection alone, the *membrana virginalis* is called "tela," cloth (3, 77, 80, 101).
62. Herrero, "Celestina's Craft: The Devil in the Skein," *Bulletin of Hispanic Studies,* 61 (1984), 344–45; 347–48. Herrero's article continues the discussion of the importance of witchcraft in *La Celestina.* His argument operates on the level of imagery and atmosphere and aims to illustrate how Celestina's demonically evil activities lend an air of terror and dread to the story. He makes no judgments of the metaliterary value of this imagery, of what it might communicate about the practices of reading and writing.
63. Alzieu, Jammes, and Lissourges, vocabulary, 329 54.
64. Covarrubias, 1010.
65. See chapt. 3.
66. Nancy K. Miller, "Arachnologies: The Woman, The Text, and the Critic," in *The Poetics of Gender* (New York: Columbia University Press, 1986), 272–73.
67. Miller, 283.
68. Genette, *Narrative Discourse,* 52.
69. Jacques Derrida, "The Double Session" in *Dissemination,* trans. Barbara Johnson (Chicago: University of Chicago Press, 1981), 182 and trans. n. 9, 182.
70. Paul Margueritte, *Pierrot Murderer of His Wife,* 1882, Schmidt, Printer (Bibliographical data from Derrida, *Dissemination,* 196 n. 20).
71. Derrida, *Dissemination,* 220.
72. Derrida, *Dissemination,* 213.
73. Jardine, 190.
74. *Our Bodies, Ourselves,* 206.
75. Derrida, *Dissemination,* 183.
76. Swietlicki, 4–5. Swietlicki's conclusion is that "*La Celestina* is both a literary masterpiece and a feminist high point in Spanish literature" (11). She believes that the work is feminist because it portrays

powerful women. *Malleus* portrays powerful women, too, but it does not valorize women. Often "feminist" criticism of canonical Spanish works is devoted to showing that the works are feminist, that is, that they can be seen, today, to portray women in a positive light. This criticism usually moves along a good/bad opposition (feminist = good, anti-feminist = bad), and the texts invariably are proved to be feminist, that is, good, and worthy of continued inclusion in the canon. Very few articles exist that leave moot the question of whether a work from the Spanish canon is "feminist" or not, and that, rather, examine a given text from a feminist perspective, using feminist theory.

77. Sigmund Freud, "Femininity," in *New Introductory Lectures on Psychoanalysis,* trans. James Strachey (New York: Norton, 1965), 117.

78. Joseph T. Snow's "Celestina's Claudina," in Miletich, 257–75, sees Celestina's memory of Claudina as an autobiographical fiction that the former uses in order to control her hearers, particularly Pármeno. Snow reads Celestina's use of Claudina as causing, inevitably, her death: "Celestina, who was smugly happy to have the figure of Claudina to manipulate, sees it lead to her own destruction" (274). In this interpretation, the critic blames Celestina for her own murder and negates the value of her woman-identified recourse to a female *auctoritas.* Snow sees Pármeno, at the moment he murders Celestina, as most "his mother's son," because Celestina says, "y aún así me trataba ella" [and even she treated me like this sometimes]—but obviously the woman's anger did not include murder. That is left up to the son who denies his matrilineage.

79. Luce Irigaray, *This Sex Which Is Not One,* trans. Catherine Porter (Ithaca: Cornell University Press, 1985), 210.

80. Irigaray, 207.

81. *Poema de mío Cid,* tirada 18, v. 375.

82. Alan Deyermond's "Hilado-Cordón-Cadena: Symbolic Equivalence in *La Celestina,*" *Celestinesca,* 1 (1977): 6–12, painstakingly shows how demonic intervention proceeds through the various threads and chains that appear in the story. He does not consider the meaning of the silk thread used to mend hymens.

83. Gilman, *The Art,* 103.

Chapter 4

1. Miguel de Cervantes, *Novela del casamiento engañoso* and *Coloquio de los perros,* in *Novelas ejemplares,* vol. 3, ed. Juan Bautista Avalle-Arce

(Madrid: Castalia, 1985). Parenthetical page references in the text are to this edition. Translations are my own.

2. See, for example, Agustín G. de Amezúa y Mayo, *Cervantes: Creador de la novela corta española*, 2 vols. (1958; reprint, Madrid: CSIC, 1982), 2:454 ff. This is particularly true, as Amezúa y Mayo points out, of Cañizares, but Estefanía has relatives in Elicia and Areusa, and, as with Celestina, a glittering chain contributes to her undoing. Also Cañizares mentions that Camacha "remediaba maravillosamente las doncellas que habían tenido algún descuido en guardar su entereza"(292) [marvelously remedied the maidens who had been careless in minding their intactness]—she is a hymen mender.

3. Joaquín Casalduero, *Sentido y forma de las Novelas ejemplares* (Madrid: Gredos, 1962), 237. Pamela Waley makes a convincing argument for the unity and interdependence of the two stories in "The Unity of the *Casamiento engañoso* and the *Coloquio de los perros*" in *Bulletin of Hispanic Studies* 34 (1957): 201–12.

4. On the reciprocal generating of the texts, see Ruth El Saffar, *Novel to Romance: A Study of Cervantes's Novelas ejemplares* (Baltimore: Johns Hopkins University Press, 1974), 80–81. The same author has written *Cervantes: El casamiento engañoso and El coloquio de los perros* (London: Grant and Cutler, 1976), an exhaustive and lucid guide to the stories.

5. Bataillon's *Erasmo y España*, trans. A. Alatorre (México City: Fondo de Cultura Económica, 1950), is an encyclopedic discussion of the influence of Erasmus's ideas in the Spanish Golden Age. He specifically discusses the Erasmian influence in *Casamiento* in "Cervantès et le mariage chrétien," *Bulletin Hispanique* 6, no. 49 (1947), 129–44. Castro elaborates on the subject in *El pensamiento de Cervantes*, ed. Julio Rodríguez-Puértolas (Barcelona: Noguer, 1980), 366–78. It is possible that Erasmus's *Colloquia* influenced Cervantes's choice of genre for the story of *Coloquio*, but Amezúa y Mayo indicates that there were many other dialogues, both contemporary and classical, from which he could choose; see Amezúa y Mayo, 417–18.

6. El Saffar notes this: "[E]ach pair [of narrators and listeners] judges as fictitious the words and deeds of the one below . . . [and] we find ourselves, as reader-critics, bound up in the fiction we have been reading"; *Novel*, 81.

7. Bataillon discusses the relationship of the picaresque to *Casamiento/Coloquio* in "Relaciones literarias" in *Suma Cervantina*, ed. J. B.

Avalle-Arce and E. C. Riley (London: Tamesis Books, 1973), 230–32. Bataillon sees the stories as influenced by, but also going beyond and satirizing, the conventions of the picaresque. It is in the interests of the present study to note that he sees the ambience of the work as more related to "el mundo antepicaresco de *La Celestina*" (232). Further commentary on the picaresque and *Casamiento/Coloquio* may be found in A. A. Parker's *Literature and the Delinquent: The Picaresque Novel in Spain and Europe* (Edinburgh: University of Edinburgh Press, 1967). Fundamental studies including work on Cervantes and the picaresque are Bataillon, *Pícaros y picaresca* (Madrid: Taurus, 1969); Castro's essay "Perspectiva de la novela picaresca" in *Hacia Cervantes* (Madrid: Taurus, 1957), 83–105; and Claudio Guillén's essays in *Literature as System* (Princeton: Princeton University Press, 1971).

8. Roberto González-Echevarría, "The Life and Adventures of Cipión," *Diacritics* 10 (Fall, 1980): 15–26; reprinted in *Cervantes*, ed. Harold Bloom (New York: Chelsea House, 1987), 108–9.

9. El Saffar, *Cervantes: El casamiento*, 25.

10. Derrida, *Dissemination*, 209–22; and Derrida, *Spurs: Nietzsche's Styles [Eperons: Les styles de Nietzsche]*, trans. Barbara Harlow (Chicago: University of Chicago Press, 1978), 47–63.

11. This is El Saffar's idea of redemption in *Casamiento/Coloquio*: "The process of recapitulation captures the past while releasing its narrator"; *Novel*, 81.

12. Waley, 205.

13. Derrida, *Spurs*, 57–59.

14. See, for example, Casalduero, 53–54.

15. Bataillon, "Mariage," 134.

16. Alban K. Forcione, *Cervantes and the Mystery of Lawlessness: A Study of El casamiento engañoso y El coloquio de los perros* (Princeton: Princeton University Press, 1984), 59. Forcione sees the Cañizares episode as the central one of the work. It is interesting to note that there were, historically, a group of women called "las Camachas" accused of witchcraft in 1571 in Montilla in the province of Córdoba. For further information, see Alvara Huerga, "El proceso inquisitorial contra la Camacha" in *Cervantes: Su obra y su mundo. Actas del I congreso internacional sobre Cervantes*, ed. Manuel Criado de Val (Madrid: Edi 6, 1981), 453–64. Amezúa y Mayo also discusses them, 456–58 and in addition thoroughly comments on the meaning of witchcraft in Cervantes's time, 461–80.

17. *Novelas ejemplares*, ed. Avalle-Arce, introduction, 28.

18. In Lacanian theory, the Symbolic is that realm which a subject enters when, cognizant of lack, he posits signifiers to represent the lost object. Babies move into the Symbolic when, at first conscious of their difference from their mother, they must use signifiers to take her place. Language functions in the Symbolic as a third term that breaks the mother/child dyad. See Juliet Mitchell, *Psychoanalysis and Feminism* (New York: Vintage, 1974); and Lacan, *Ecrits: A Selection*, trans. Alan Sheridan (New York: Norton, 1977).

19. Jacqueline Rose, introduction II, in Lacan, *Feminine Sexuality*, 31.

20. That this skill was commonly attributed to witches is confirmed in Kramer, pt. 2, quest. 1, chap. 8, 122.

21. Amezúa y Mayo, 2:451-61.

22. I follow the system for counting episodes advanced by El Saffar in *Cervantes:* El casamiento, 38 ff. Other suggestions appear in Alan Soons, "An Interpretation of the Form of *El casamiento engañoso y coloquio de los perros*," *Anales cervantinos* 9 (1961-62): 203-12; and in Maurice Molho, "Remarques sur *Le Mariage trompeur et Colloque des chiens*" in his translation (Paris, 1970), 11-95.

23. This scene, in miniature, shows how the action of a deviant character provides the motive force for narrative.

24. The story, thus, begins and ends affirming that the dogs have always been speaking subjects, despite the fact that until the night of *Coloquio*, they were mechanically incapable of producing the sounds of speech.

25. L. J. Woodward, "*El casamiento engañoso y el coloquio de los perros*," *Bulletin of Hispanic Studies* 36 (1959): 82.

26. Avalle-Arce and others think that there may be allusions to the *Aeneid*, Book 6, "Parcere subiectis et debellare superbos" and to Luke 1:51-52 in the prophecy; *Novelas ejemplares*, ed. Avalle-Arce, 3:294 n. 236.

27. See Kramer, pt. 1, chap. 11, and pt. 2, chap. 13.

Chapter 5

1. [Miguel de Cervantes?] *La tía fingida*, in *Novelas ejemplares*, 3: 323-70. Translations are my own. There is a bowdlerized English translation by Walter K. Kelly, in *The Exemplary Novels of Miguel de*

Cervantes Saavedra, to which Are Added El buscapié, *or* The Serpent; *and* La Tía fingida, *or* The Pretended Aunt (London: H. G. Bohn, 1855). My translations improvise on this.

 2. E. T. Aylward, *Cervantes: Pioneer and Plagiarist* (London: Tamesis Books, 1982), 13.

 3. See, for example, J. T. Medina, *Novela de* La tía fingida, *con anotaciones a su texto y un estudio crítico acerca de quien fué su autor* (Santiago, Chile: Imprenta Elzeviriana, 1919), 391–412; and Julio Rodríguez Luís, *Novedad y ejemplo de las novelas de Cervantes*, 2 vols. (Madrid: Edíciones José Porrúa Turanzas, 1980, 1984), 2:84–85.

 4. R. Foulché-Delbosc, "Etude sur *La tía fingida.*" *Revue Hispanique,* 6 (1899): 303–4.

 5. See Medina and Rodríguez Luís.

 6. For very thorough bibliographical data, see Aylward and Foulché-Delbosc.

 7. Aylward, 13.

 8. Cervantes, "Prólogo," *Novelas ejemplares,* ed. Sergio Fernández (Mexico City: Porrúa, 1981), 2.

 9. The relationship, in writing, of pen/*plume*/*pluma* and phallus is amply illustrated in Derrida, *Dissemination,* 271–79.

 10. D. Isidro Bosarte, *Diario de Madrid,* 9–10 June, 1788, in Foulché-Delbosc, 289–93.

 11. Foulché-Delbosc, 289.

 12. Foulché-Delbosc, 290.

 13. Aylward, 18–19.

 14. Aylward, 19.

 15. Arrieta in Foulché-Delbosc, 275.

 16. Aylward, 22 quoting Arrieta in Foulché-Delbosc, 262–63.

 17. Aylward, 22.

 18. Aylward, 22.

 19. Navarrete quoted in Aylward, 22, from *La tía fingida,* ed. Adolfo Bonilla y San Martín (Madrid: V. Suárez, 1911), 15–16.

 20. Aylward, 24, quoting D. B. J. Gallardo, *"La tía fingida ¿Es novela de Cervantes?"* in *Obras escogidas de Don Bartolomé José Gallardo,* ed. Pedro Sáinz y Rodríguez (Madrid: Los Clásicos Olvidados, 1928), 151.

 21. P. Julián Apráiz, *Juicio de* La tía fingida (Madrid: Real Academia Española, 1906), 8.

 22. Medina, xxviii.

23. Bonilla y San Martín, 7.
24. Rodríguez Luís, 2:99.
25. Aylward, 28.
26. Irigaray, 172.
27. For example, the seminal studies of Amezúa y Mayo, El Saffar, and Casalduero do not mention the text.
28. In *Novelas ejemplares,* ed. Fernandez, *La tía* is separated from the rest of the stories by asterisks in the table of contents, and by a disclaimer and a separate title page at the end of the book.
29. *Novelas ejemplares,* ed. Avalle-Arce, 32–33.
30. These usages appear throughout the text of *La Celestina.*
31. Apráiz, 192.
32. Irigaray, 185.
33. Irigaray, 186.
34. This is reminiscent of the gold chain that Calisto gives to Celestina and of Campuzano's in *Casamiento.*
35. That this bodily eruption is quasi-orgasmic is supported by the following anecdote told to me by a friend. In a sex education class, a teacher pressed to explain what an orgasm felt like responded that the closest thing to it was a good sneeze. Rodgers and Hammerstein allude to this, also, in the song "My Favorite Things" from *The Sound of Music.*
36. The term *puta honrada* did exist at this time in vulgar Spanish, as an insult.

Chapter 6

1. Aylward, 14.
2. The character has three names: *Urraca,* her given name; *Trotaconventos,* her nickname; and *buen amor,* which might be called her narratological name.
3. See Ruíz. Stanza and verse numbers in the text refer to this edition.
4. For a further elaboration of this argument, see the chapter on *Libro de buen amor* in Castro, *The Structure of Spanish History,* trans. Edmund L. King (Princeton: Princeton University Press, 1964), 397 ff.
5. Castro, 397 n. 3.
6. Francisco Márquez Villanueva advances this theory in his *Relecciones de literatura medieval* (Seville: Servicio de publicaciones de la

Note to Page 115

Universidad, 1977), 52–55. This concept of *buen amor* is attributed to Arabs and troubadours (possibly Albigensians) and was seen by orthodoxy as heretical. *Loco amor,* or fornication, was seen as immoral. Both were censured primarily because they involve sexual relations outside matrimony, that is, outside church control.

7. Castro, *Realidad,* 80ff. See chap. 3, n. 21 in this volume.

Bibliography

Alfonso X, el Sabio. *Antología*. Ed. Margarita Peña. México City: Porrúa, 1973.
Alzieu, Pierre, Robert Jammes, and Yvan Lissourges, eds. *Floresta de poesías eróticas del siglo de oro*. Toulouse: France-Ibérie Recherche, 1975.
Amezúa y Mayo, Agustín G. de. *Cervantes: Creador de la novela corta española*. 2 vols. 1958. Reprint. Madrid: CSIC, 1982.
Apráiz, P. Julián. *Juicio de* La tía fingida. Madrid: Real Academia Española, 1906.
Aretino, Pietro. *I Raggionamenti*. Ed. Antonino Foschini. Milan: Corbaccio, 1951.
Arias, Consuelo. "El espacio femenino en tres obras del medioevo español: de la reclusión a la transgresión." *La Torre* 1, nos. 3–4 (1987): 365–88.
Avalle-Arce, Juan Bautista, and Riley, E. C., eds. *Suma Cervantina*. London: Tamesis Books, 1973.
Aylward, E. T. *Cervantes: Pioneer and Plagiarist*. London: Tamesis Books, 1982.
Bal, Mieke. *Lethal Love: Feminist Literary Readings of Biblical Love Stories*. Bloomington: Indiana University Press, 1987.
Barth, Gaspar. *Pornoboscodidascalus*. Frankfurt, 1624.
Barthes, Roland. *Le plaisir du texte*. Paris: Editions du Seuil, 1973.
———. *The Pleasure of the Text*. Trans. Richard Miller. New York: Hill and Wang, 1975.

Bataillon, Marcel. "Cervantès et le Mariage Chrétien." *Bulletin Hispanique* 6, no. 49 (1947): 129-44.
———. *Erasmo y España*. Trans. A. Alatorre. México City: Fondo de Cultura Económica, 1950.
———. *La Celestine selon Fernando de Rojas*. Paris: Didier, 1961.
———. *Pícaros y picaresca*. Madrid: Taurus, 1969.
———. "Relaciones literarias." In Avalle-Arce, 230-32.
Bell, Millicent. "Narrative Gaps/Narrative Meaning." *Raritan*, October/November, 1986, 84-101.
Bloom, Harold, ed. *Cervantes*. New York: Chelsea House, 1987.
Bonilla y San Martín, Adolfo, ed. *La tía fingida*. Madrid: V. Suárez, 1911.
Bosarte, D. Isidro. *Diario de Madrid*. In Foulché-Delbosc, 289-93.
Boston Women's Health Book Collective. *The New Our Bodies, Ourselves*. Second Edition. New York: Simon and Schuster, 1984.
Bravo-Villasante, Carmen, and Ruíz, Higinio. "Talavera de la Reina ¿lugar de acción de *La Celestina*?" *Actas del II Congreso Internacional de Hispanistas*. Nijmegen, 1967.
Cano, Vicente. "La función dramática del engaño en la *Celestina*." *Kanina* (Costa Rica) 8 (1984): 77-82.
Casalduero, Joaquín. *Sentido y forma de las Novelas ejemplares*. Madrid: Gredos, 1962.
Castro, Américo. *España en su historia*. Buenos Aires, 1948.
———. *Hacia Cervantes*. Madrid: Taurus, 1957.
———. *The Structure of Spanish History*. Trans. Edmund L. King. Princeton: Princeton University Press, 1964.
———. *La Celestina como contenida literaria: castas y casticismos*. Madrid: Revista de Occidente, 1965.
———. *La realidad histórica de España*. Mexico City: Porrúa, 1966.
———. *De la edad conflictiva: crisis de la cultura española en el siglo XVII*. Madrid: Taurus, 1976.
———. *El pensamiento de Cervantes*. Ed. Julio Rodríguez-Puértolas. Barcelona: Noguer, 1980.
Cervantes Saavedra, Miguel de. *Le Mariage trompeur et Colloque des chiens*. Trans. Maurice Molho. Paris, 1970.
———. *Don Quijote de la Mancha*. 2 vols. Ed. Martín de Riquer. Barcelona: Juventud, 1971.
———. *Exemplary Novels*. Trans. Walter K. Kelly. London: H.G. Bohn, 1855.

Bibliography

———. *Novelas ejemplares.* 3 vols. Ed. Juan Bautista Avalle-Arce. Madrid: Castalia, 1985.

———. *Novelas ejemplares.* Ed. Sergio Fernández. Mexico City: Porrúa, 1981.

Chevalier, Maxime. *Lecturas y lectores en la España del siglo xvi y xvii.* Madrid: Turner, 1976.

Covarrubias y Orozco, Sebastián de. *Tesoro de la lengua castellana o española.* Madrid: Turner, 1970.

Criado de Val, Manuel, ed. *Cervantes: Su obra y su mundo. Actas del I congreso internacional sobre Cervantes.* Madrid: Edi 6, 1981.

Czarnocka, Halina. "Sobre el problema del espacio en la *Celestina.*" *Celestinesca* 9, no. 2 (1985): 65–74.

Daly, Mary. *Gyn/Ecology: The Metaethics of Radical Feminism.* Boston: Beacon Press, 1978.

Derrida, Jacques. *Spurs: Nietzsche's Styles [Eperons: Les Styles de Nietzsche].* Trans. Barbara Harlow. Chicago: University of Chicago Press, 1978.

———. *Dissemination.* Trans. Barbara Johnson. Chicago: University of Chicago Press, 1981.

Deyermond, Alan S. *The Petrarchan Sources of* La Celestina. Oxford: Oxford University Press, 1961.

———. "Hilado-Cordón-Cadena: Symbolic Equivalence in *La Celestina.*" *Celestinesca* 1 (1977): 6–12.

Deyermond, Alan, ed. *Historia y crítica de la literatura española.* 8 vols. Barcelona: Editorial Crítica, 1980.

Eagleton, Terry. *Literary Criticism: An Introduction.* Minneapolis: University of Minnesota Press, 1983.

Earle, P. G. "Love Concepts in *La cárcel de amor* and *La Celestina.*" *Hispania* 39 (1956): 92–96.

El Saffar, Ruth. *Novel to Romance: A Study of Cervantes's* Novelas ejemplares. Baltimore: Johns Hopkins University Press, 1974.

———. *Cervantes:* El casamiento engañoso *and* El coloquio de los perros. London: Grant & Cutler, 1976.

———. *Beyond Fiction: The Recovery of the Feminine in the Novels of Cervantes.* Berkeley: University of California Press, 1984.

Erasmus, Desiderius. *El Enquiridión o manual del caballero cristiano.* Trans. Alonso Fernández de Madrid (ca. 1475–1559). Ed. Dámaso Alonso. Madrid: S. Aguirre, 1932.

———. *Coloquios.* In Marcelino Menéndez y Pelayo. *Orígenes de la novela,* 4:149–249. Madrid: Bailly-Bailliere, 1915.
Ferré, Rosario. "*Celestina* en el tejido de la *cupiditas.*" *Celestinesca* 7, no. 1 (May, 1983): 3–16.
Forcione, Alban K. *Cervantes and the Mystery of Lawlessness: A Study of* El casamiento engañoso *y* El coloquio de los perros. Princeton: Princeton University Press, 1984.
Foulché-Delbosc, R. "Etude sur *La tía fingida.*" *Revue Hispanique* 6 (1899).
Freud, Sigmund. "Femininity." In *New Introductory Lectures on Psychoanalysis.* Trans. James Strachey. New York: Norton, 1965.
Gallardo, Bartolomé José. *Obras escogidas.* Ed. Pedro Saínz y Rodríguez. Madrid: Los Clásicos Olvidados, 1928.
Genette, Gérard. *Narrative Discourse: An Essay in Method.* Trans. Jane E. Lewin. Ithaca: Cornell University Press, 1980.
———. *Figures of Literary Discourse.* Trans. Alan Sheridan. New York: Columbia University Press, 1982.
Gerli, E. Michael. *Alfonso Martínez de Toledo.* Boston: Twayne, 1976.
Gilman, Stephen. *The Art of* La Celestina. Madison: University of Wisconsin Press, 1956.
———. *The Spain of Fernando de Rojas: The Intellectual and Social Landscape of* La Celestina. Princeton: Princeton University Press, 1972.
González-Echevarría, Roberto. "The Life and Adventures of Cipión." *Diacritics* 10 (Fall, 1980): 15–26. In Bloom, 108–9.
Guillén, Claudio. *Literature as System.* Princeton: Princeton University Press, 1971.
Herrero, Javier. "Celestina: The Aging Prostitute as Witch." In *Aging in Literature,* ed. L. and L. M. Porter, 31–47. Troy, Mich.: International Book Publishers, 1980.
———. "Celestina's Craft: The Devil in the Skein." *Bulletin of Hispanic Studies* 61 (1984).
Huerga, Alvara. "El proceso inquisitorial contra la Camacha." In Criado de Val, 453–64.
Ingarden, Roman. *The Literary Work of Art: An Investigation on the Borderlines of Ontology, Logic, and Theory of Literature.* Trans. George G. Grabowicz. Evanston: Northwestern University Press, 1973.
Irigaray, Luce. *This Sex Which Is Not One.* Trans. Catherine Porter. Ithaca: Cornell University Press, 1985.

Iser, Wolfgang. *The Act of Reading: A Theory of Aesthetic Response.* Baltimore: Johns Hopkins University Press, 1978.
Jardine, Alice. *Gynesis: Configurations of Woman and Modernity.* Ithaca: Cornell University Press, 1985.
Kamen, Henry. *Inquisition and Society in Spain.* London: Weidenfeld and Nicolson, 1985.
Kellman, Steven G. *Loving Reading: Erotics of the Text.* Hamden, Conn.: Archon, 1985.
Kramer, Heinrich, and Sprenger, James. *Malleus Maleficarum.* Ed. the Rev. Montague Summers. New York: Dover, 1971.
Lacan, Jacques. *Ecrits: A Selection.* Trans. Alan Sheridan. New York: Norton, 1977.
―――. *Feminine Sexuality.* Trans. Jacqueline Rose. Ed. Juliet Mitchell and Jacqueline Rose. New York: W. W. Norton, 1982.
Lea, Henry Charles. *A History of the Inquisition in Spain.* 4 vols. New York: Macmillan, 1906–7.
Lida de Malkiel, María Rosa. *La originalidad artística de* La Celestina. Buenos Aires: EUDEBA, 1962.
Macherey, Pierre. *A Theory of Literary Production.* Trans. Geoffrey Wall. London: Routledge Kegan Paul, 1978.
Maravall, José Antonio. *El mundo social de* La Celestina. Madrid: Gredos, 1964.
Margueritte, Paul. *Pierrot Murderer of His Wife.* In Derrida, *Dissemination,* 196.
Márquez Villanueva, Francisco. *Relecciones de literatura medieval.* Seville: Seville University Press, 1977.
Martínez de Toledo, Alfonso. *Arcipreste de Talavera o Corbacho.* Ed. Joaquín González Muela. Madrid: Castalia, 1984.
Medina, J. T. *Novela de* La tía fingida, *con anotaciones a su texto y un estudio crítico acerca de quien fué su autor.* Santiago, Chile: Imprenta Elzeviriana, 1919.
Menéndez y Pelayo, Marcelino. *Celestina.* Vigo: E. Krapf, 1899.
―――. *Origenes de la novela.* 4 vols. Madrid: Bailly-Baillière, 1905–10.
―――. *Historia de los heterodoxos españoles.* 2 vols. 1882. Reprint. México City: Porrúa, 1983.
Miletich, John S., ed. *Hispanic Studies in Honor of Alan D. Deyermond: A North American Tribute.* Madison: Hispanic Seminary of Medieval Studies, 1986.

Miller, Nancy K. "Arachnologies: The Woman, the Text, and the Critic." In *The Poetics of Gender,* ed. Nancy K. Miller, 270–96. New York: Columbia University Press, 1986.

Mitchell, Juliet. *Psychoanalysis and Feminism.* New York: Vintage, 1974.

Moratín, Leandro Fernández de. *Orígenes del teatro español.* Vol. 1 of *Obras,* 4 vols. Madrid: Aguado, 1830–31.

Oñate, María del Pilar. *El feminismo en la literatura española.* Madrid: Espasa-Calpe, 1938.

Parker, A. A. *Literature and the Delinquent: The Picaresque Novel in Spain and Europe.* Edinburgh: University of Edinburgh Press, 1967.

Poema de mío Cid. Ed. Ramón Menéndez Pidal. 1911. Reprint. Madrid: Espasa-Calpe, 1980.

Rank, Jerry R. "Narrativity and *La Celestina.*" In Miletich, 235–46.

Riley, E. C. *Cervantes's Theory of the Novel.* Oxford: Oxford University Press, 1962.

Riquer, Martín de. "Fernando de Rojas y el primer acto de *La Celestina.*" *Revista de Filología Española* 41 (1957).

Rodríguez Luís, Julio. *Novedad y ejemplo de las novelas de Cervantes.* 2 vols. Madrid: Ediciones José Purrúa Turanzas, 1980, 1984.

Rojas, Fernando de. *The Spanish Bawd.* Trans. James Mabbe. London: J. B., 1631.

——— . *Celestina.* Trans. Mack Hendricks Singleton. Madison: University of Wisconsin Press, 1958.

——— . *The Spanish Bawd.* Trans. J. M. Cohen. Harmondsworth: Penguin, 1964.

——— . *The Celestina: A Novel in Dialogue.* Trans. Lesley Bird Simpson. Berkeley: University of California Press, 1971.

——— . *Tragicomedia de Calisto y Melibea (La Celestina).* Ed. Dorothy S. Severin. Madrid: Alianza, 1979.

Ruggiero, Michael J. *The Evolution of the Go-Between in Spanish Literature through the Sixteenth Century.* Berkeley: University of California Press, 1966.

——— . "*La Celestina*: Didacticism Once More." *Romanische Forshungen* 82 (1970): 56–64.

Ruíz, Juan, Arcipreste de Hita. *Libro de buen amor.* Ed. Jacques Joset. 2 vols. Madrid: Espasa-Calpe/Clásicos castellanos, 1974.

Russell, P. E. "The Art of Fernando de Rojas." *Bulletin of Hispanic Studies* 39 (1957): 160–67.

——— . *Temas de* La Celestina *y otros estudios.* Barcelona: Ariel, 1978.

Bibliography

Sartre, Jean-Paul. *What Is Literature?* Trans. Bernard Frechtman. Gloucester, Mass.: Peter Smith, 1978.

Schizzano-Mandel, Adrienne. *La Celestina Studies: A Thematic Survey and Bibliography, 1824–1970.* Metuchen, N.J.: Scarecrow Press, 1971.

Schor, Naomi. *Breaking the Chain: Women, Theory, and French Realist Fiction.* New York: Columbia University Press, 1985.

Shepard, Sanford. *Lost Lexicon: Secret Meanings in the Vocabulary of Spanish Literature During the Inquisition.* Miami: Ediciones Universal, 1982.

Sieber, Harry. *Language and Society in "La vida de Lazarillo de Tormes."* Baltimore: Johns Hopkins University Press, 1978.

Smith, Paul Julian. *Writing in the Margin: Spanish Literature of the Golden Age.* Oxford: Oxford University Press, 1988.

Snow, Joseph T., ed. "Un cuarto de siglo de interés en *La Celestina*, 1949–1975: documento bibliográfico." *Hispania* 59 (1976): 610–60.

——. "Celestina's Claudina," in Miletich, 257–75.

Soons, Alan. "An Interpretation of the Form of *El casamiento engañoso y coloquio de los perros.*" *Anales cervantinos* 9 (1961–62): 203–12.

Stratton, Jon. *The Virgin Text.* Tulsa: University of Oklahoma Press, 1987.

Suleiman, Susan Rubin. *Authoritarian Fictions: The Ideological Novel as a Literary Genre.* New York: Columbia University Press, 1983.

Swietlicki, Catherine. "Rojas' View of Women: A Reanalysis of *La Celestina.*" *Hispanófila*, September 1985.

Szasz, Thomas S. *The Manufacture of Madness.* New York: Harper and Row, 1970.

La tía fingida. [Miguel de Cervantes?] In *Novelas ejemplares.* Ed. Avalle-Arce; and ed. Fernandez.

Traupman, John C., ed. *The New College Latin and English Dictionary.* New York: Bantam Books, 1966.

Valbuena Prat, Angel, ed. *La novela picaresca española.* Madrid: Aguilar, 1943.

Valdés, Juan de. *Diálogo de la lengua.* Ed. José F. Montesinos. Madrid: Espasa-Calpe 1969.

Vives, Juan Luís. *De Institutione Feminae Christianae.* Antwerp, 1524.

Waley, Pamela. "The Unity of the *Casamiento engañoso* and the *Coloquio de los perros.*" *Bulletin of Hispanic Studies* 34 (1957): 201–12.

Welles, Marcia. *Arachne's Tapestry: The Transformation of Myth in Seventeenth-Century Spain.* San Antonio: Trinity University Press, 1986.

Whitbourn, Christine J. *The "Arcipreste de Talavera" and the Literature of Love.* Hull: Hull University Press, 1970.

Woodward, L. J. "*El casamiento engañoso y el coloquio de los perros.*" *Bulletin of Hispanic Studies* 36 (1959): 80–87.